W9-DJC-395

Portrait of Mr. B

PORTRAIT

of

MR. B

Photographs of

GEORGE BALANCHINE

with an essay by Lincoln Kirstein

A Ballet Society Book

The Viking Press · New York

Contents

Foreword

PETER MARTINS

The man and the artist are the same, of course, but it is the man I think about, the one I remember. He was totally practical, realistic, fast to make decisions, and he liked those around him to be the same way. In class he would interrupt his teaching with anecdotes, reminiscences, jokes. He avoided ballet terms, preferring to sketch what he wanted with his hands, demonstrating or describing movements in the plainest language. Perhaps he felt we would become impatient or bored if he used the classical terminology; perhaps he meant to keep us always in the real world, to keep the pressure down, to keep us relaxed.

He had a brilliant gift for cuttingly sharp imitations. Often they were of people with whom he had worked in the past, legendary names to us—my favorite was his demonstration of his one and only tennis game with Serge Lifar, both of them on court for the first time, elegantly attired, holding their racquets like shields or over their heads—and, more terrifying and deadly, they were of us. One effect of this was that we retaliated when he wasn't around with precise and affectionate imitations of him. He was the one who set us the model and manner for our revenge. What he bred in part, then, sometimes seems like a pack of sharp-tongued, witty, demanding mimics. We aren't easily impressed and we can't be conned and we have a special dislike for the pretentious. While we cultivate his steady, dispassionate tone, I think we are less good at his compassion and his patience.

With his fixed purpose and assurance, he was one of the great poets of dance. There is no contradiction in that: it means simply that he created his extraordinary ballets by the most efficient and sensible of means. He knew what work was to be done, and he eliminated from his life everything that was interfering, trivial, or excessive. The dances he made are like that too—nothing wasted, everything essential. He made the movements seem inevitable: when you listen to any music to which he set choreography, you can see his work and you know there are no choices but the choices he made. He added no special effects; he never attempted to put his personal imprint on the work, though it is unmistakably his.

Now that I have inherited some of his responsibilities, I learn each day more of what his life must have been like. During the years we worked together, years when I danced for him and made ballets for him, I believed I understood him perfectly. I subjected him to careful scrutiny, and I worked hard to predict how he would respond to any situation. But I realize now that I knew little about the feelings and purposes behind his actions and responses. The pressures that drive me to barely contained fury left him apparently cool, fresh, collected, eager to move on to the next problem. How he managed to deal with the never-ending demands amazes me, for every day he taught or coached or gave fatherly counsel on all matters to his dancers, readied the current repertoire, instructed a staff, directed the School—and after all that he could still walk into a studio and make a ballet that more than likely would be a great ballet, or even a masterpiece.

My amazement is not so much at his control over his time, but that the mundane duties didn't deplete the energies he needed for his creative work. He hid his exhaustion when he had to, for he knew that his dancers and the rehearsal pianist were waiting, the studio available for just the allotted period. He never cancelled scheduled sessions, for he had too much regard and respect for the needs of those in his company who were his responsibility. And if anyone else had to bow out, then he would work around them. He utilized all the available time, adjusted to any unforeseen difficulties, and made the fullest use of what he had. His gift was to get the best, the maximum, from everyone.

He choreographed with unequalled speed, and he didn't fuss and endlessly refine. He would talk about assembling parts, that it was a matter of being a craftsman; he loathed mention of creativity or inspiration—these were not practical items. Some part of him relished being a management executive, calculating and manipulative, but his administrative and shaping abilities are not so often remarked on—perhaps because they were the attributes of a man who was soft-spoken and courteous, a generous counselor.

By building and keeping his company in good repair, he safeguarded the art he loved. The details of maintenance never fazed him, and he was everywhere. At the end of the day, he would go himself to the main rehearsal hall, turn out the lights, and then go downstairs to make sure the office lights were out. "Con Ed is very expensive," he explained to me. "If I don't turn off, lights will be on all night. Do you know how much you save if you turn lights off? Millions!"

Through the 1930s and most of the 1940s he had gone from company to company (and from musical comedies to operas, then to movies and

to the circus), and his achievements must have seemed to him dependent on the whim of circumstance. Naturally, he was willing to try anything, but once the chance came for a company of his own, he must have determined he would do everything necessary to insure its continued existence. His ballets were made on dancers on hand at the time. They stressed those dancers' abilities and concealed their deficiencies yet today when we see these works we feel no limitation or absence in the choreography: what is there is sufficient. In casting and planning his company's repertoire he would worry about which dancers might need to be in a new work, which dancers needed different roles, what new partnerships should be tried, who should be set challenges, who should be set his usual tests of character—and especially he considered what the audience ought and should see. There were no indulgent experiments, no ego trips, no self-promotions. He provided what was needed.

When a ballet of his that had been absent from the repertoire for some seasons reappeared, he would stand in the wings and watch its performance critically. The way he scrutinized his work made him seem at those moments vulnerable and unsure, as if he was wondering if it were good or bad, or if it was anything at all. At the end of a passage, surprised and impressed by his own choreography, he'd lean over to me and say, "You know, dear, this part is not so bad." When the ballet was over, he'd raise a finger and shake his hand back and forth emphatically. With a smile, he'd say, "You see, not so bad at all. It's good." At the work's next performance he would be back in the wings, head lifted, eyes narrowed.

From time to time, dancers left the company, dissatisfied with how they were being treated or believing he did not fully understand their needs. Some of them returned—he had a sense that eventually everyone would come around and wish to return, and if they didn't, well, good; and some he didn't allow back—not to punish them but because in their absence their places had been filled and he wouldn't push the other dancers aside. He prized in dancers the ability to be objective about their talents and place, and self-inflated notions about their rights and privileges irritated him, though he forgave and never abused the truly ignorant. He made his company understand that dancing was a rare service, and he was angry at those who dishonored the profession or who he thought took their gift lightly—an irresponsibility that was sacrilege to him. His belief and trust in music and classical ballet were absolute and his deep motive was to assure that the classical ballet idiom would continue for generations. He had a love for both, and as ballet master he knew he was creating the link that bound its past to its future.

Life can never be all you want it to be; therefore, to protect what is important, you have to set rules for yourself, you must take charge of your life. He wasn't much given to delegating responsibility, and when he did he made sure things were done his way, since that insured there would be minimal interference with the work to be done. This self-assurance and trust in his ideal allowed him to sustain complaints from within and without the company. In all things he was flexible, except when it came to listening to advice or taking criticism. About ballet, he knew that he was the ultimate authority, that he knew best. His dancers were the blades of grass and he the gardener, he once told me. He would occasionally listen to political leaders who shared his politics, approve of certain philosophical viewpoints, read the Bible, and listen to music—but he wasn't interested in listening to the remainder of the human race. He knew better, and in ballet he knew better than anyone.

His last advice to me about continuing the company was: Declare war. Don't accept anything you don't believe in. Begin from scratch, if you need to. If my set-up doesn't work for you, change it. But those who lived and worked with him knew his concerns and priorities. He had assured the future. We believe in that future because of his commitment to it. Modest as he was, and great as he was, he must have had that same small wish which all humanity shares, that all things might die with him, but immeasurably greater than that was his wish that all would continue.

Portrait of Mr. B

Psalm 150

Praise ye the Lord.
Praise God in his sanctuary:
Praise him in the firmament of his power.
Praise him for his mighty acts:
Praise him according to his excellent greatness.
Praise him with the sound of the trumpet:
Praise him with the psaltery and harp.
Praise him with the timbrel and dance:
Praise him with stringed instruments and organs.
Praise him upon the loud cymbals:
Praise him upon the high sounding cymbals.
Let every thing that hath breath praise the Lord.
Praise ye the Lord.

A Ballet Master's Belief

LINCOLN KIRSTEIN

For Father Adrian

I

WHEN George Balanchine set foot on Manhattan in the autumn of 1933, he and his colleagues were so preoccupied with confusing circumstances, inevitable in founding any ambitious institution, that while formulation of an overall educational morality was not ignored, its expression was delayed. However, after our fledgling School of American Ballet incorporated itself as licensed by the Board of Regents of the State of New York, and opened on January 2, 1934, a policy, latent but dormant, was fermenting. Over the next fifty years it would be distilled, and its taste and temper become clear. This metaphysic, or body of belief, a credence that surpassed concern for mere physical mastery, determined our destiny, as well as the destiny of those ballet companies which eventually came to employ the dancers our school had trained. Only after Balanchine's death does his moral rigor seem definable, although it had long been visible. What he lived, taught, and invented ballets by was a constant employment of traditional guidelines for considerate behavior. While these precepts would never be codified as curriculum in any catalogue, they determined instruction and practice.

Odd parents, a few very odd, commenced bringing children—mostly girls, too tall, short, or plump—to be auditioned by this young ballet master, who, not yet known to America, had already been interviewed by the dance critic of *The New York Times*. One woman asked him, after he'd inspected her daughter in practice class, "Will she dance?" What she meant was, "Do you think she is beautiful and talented, as a child, and will she be a star?" A middle-class American mother was seeking a prognosis, as from an allergist about her child's rash. The putative ballerina clung to Mummy's skirt, exhibiting filial attachment worthy of a Shirley Temple. Balanchine was unassertive, slim, no longer boyish, and, with his grave, alert mannerliness, the more daunting in his authority, instinctive and absolute. He hesitated, perhaps to make sure he would be understood; she repeated her question, "Will my daughter dance?" A Delphic response was the reply she received, sounding more oracular couched in French, although the sound of its

15

meaning was plain enough through its four transparent cognates: "*La Danse, Madame, c'est une question morale.*"

The dance as a moral consideration. The abstractness of the answer, in its hardy phrasing, may have seemed even more puzzling than its pronouncement in French. "*Morale?*" Morals? Morality? Immorality? Ancestral seventeenth-century Puritans in Plymouth, Salem, Boston, Providence, New Haven, founding theological seminaries which would mutate into influential seats of teaching if less frequently of learning, had provided the mid-twentieth-century American with a curious inversion of the word "morality." John Harvard, Cotton Mather, Elihu Yale, and their ilk denounced "dancing" as devil's business, the fancy of whoredoms, a relic of the Caroline court, of the corruption of divine kingship. Faced with exile, a trackless continent, savage enemies, starvation, an imponderable future, God-fearing pioneers needed every ounce of muscular energy just in order to survive. Jehovah had chastised a tribe frolicking in exile before a golden calf. Waste motion, especially that kindled by animal spirits, was not to be spent ecstatically or mindlessly. Witch-hunters contrived, with self-defensive ferocity, to salvage their irrepressible flock.

As a reaction, or indeed a revolt, against such historical conditioning, our own permissive epoch—thanks to pragmatism, behaviorism, Freud, and "freedom"—believes that somatic muscular instinct can, and indeed must, be identified with every born creature's right to "life, liberty and the pursuit of happiness," but with individual personal choice, no matter what the circumstance of birth or qualification may be, regardless of class or color. Any vast preoccupation with formidable definitions of good or evil, of morality itself, has become an inhibition on that guaranteed liberty. Limits imposed on available satisfaction, however brainless or fashionable, are disdained as a restriction on natural gifts that any or all of God's children (few of whom are taught to believe in Him) may, with promiscuous benevolence, accidentally be granted. Corsets beset Isadora Duncan; she tossed them off: hence any American is free to dance as she or he sees fit, presuming we possess a conscious choice.

After a long despairing revolutionary war for political independence, a frightful civil rebellion, participation in a first world war, and despite rumbles and ensuing depression from 1929, the United States in 1934 was hypnotized by the illusion of limitless possibility. Animal instinct was manumission. Restrictive rules for the cultivation of modern art, particularly modern dance, were condemned as not only retardative, but un-American. Any girl-child, given a break, might hope to be—

perhaps not yet President, but at least a baby movie star. "Morality" was an attack on optimism, hedonism, a straitjacket on compulsive free will, on the full play of one's instincts, a hindrance from which only backward or exhausted European academies might be withering.

Mother and fidgety daughter lingered irresolutely in the small shabby foyer of the School of American Ballet at 59th Street and Madison Avenue—a space that, some thirty years before, Paris Singer had leased for Isadora Duncan. She, a canonized immoralist and freedom fighter, had kept her small Russian students from entering the Bolshoi Opera House, fearful lest their innocence be corrupted by the glory of what was left of an imperial dynastic ballet company. Her own heroic counter-morality had done what it could to exorcise the ghosts of those Pilgrim Fathers who proscribed lewd behavior around the maypole at Merry-mount. With the puritanical triumph, the profession of theatrical dancer was cursed on this continent for the next two and a half centuries.

Isadora gained her personal victory, tragic as it may have been. Martha Graham, her liberated successor, because of her own feminist morality, won a more fruitful and lasting career. In 1934, modern dance was exulting in the progressive assertion of experiment, in the endless duel between the innovator and tradition. Here the influence was an inheritance from Emerson, Thoreau, and Whitman, subsequently homogenized in the blanket educational reformative attitude of William James and John B. Watson. Classic traditional academic ballet, "artificial" in its graceful historicity, seemed to most American progressive educators, wherever they recognized its fragile presence, not only played out but, worse, immoral. It now even menaced our shores as an alien invasion. The dance critic of *The New York Times*, after viewing Balanchine's debut on Broadway with a provocative repertory, advised him to sail back to Paris as soon as possible.

Sadly, the anxious and disgruntled mother reclaimed her restless hopeful. Unsatisfied, facing dismissal, she thanked Balanchine "for his time," a gesture that was also an accusation against a foreigner's lack of sympathy. Bewildered, but estimating that little enough had been risked or lost, they vanished. Soon came hundreds like them. Meanwhile, Balanchine advanced that moral substructure on which his school's regimen was founded.

II

A lady I've known since childhood, with whom I share interests in "art," but who is moved more by "literature" than listening to music or looking at dancing, asked me, when she heard Balanchine was terminally ill, "Was he, in any sense, 'religious'?" To anyone who had the least contact with him, this seemed less an ignorant than an astonishing question.

Balanchine was in every sense "religious" in its most accepted dictionary definition. His observance of the rites of Russian Orthodoxy was inborn and unswerving. St. Petersburg's ballet school, which was paid from the Tsar's privy purse and which he entered in 1913, had its own chapel and priest (as do West Point, Annapolis, and the Air Corps Academy).

As a "liberal" or even "revolutionary" student attracted to progressive expression in music and the plastic arts, in the open atmosphere following Lenin's October victory, he arranged choreography for the reading of Alexander Blok's poem *The Twelve* by a choir of fifty in 1923. He was enthusiastic about Meyerhold and Mayakovsky, but he had small interest in factional politics of the day. In later life, gross social programs for amelioration of the human condition meant far less to him than specific, minimal benefits. His affecting impersonation onstage as Don Quixote was echoed domestically when he dedicated his company's performances toward Italian earthquake relief, or when he bought bullet-proof vests for New York policemen.

For him, Lord God in one big-bang "created" the cosmos, which existed before time. After that, everything was discovery or invention. Two epithets he particularly detested, though they were frequently invoked to qualify his "genius," were "creative" and "original." The first, he felt, was the more false; only less offensive was "original" or its twin, "authentic." Any unique human explosion of initiative was usually mutation, but, more often, dilution. As for "genius," the word rarely signified contact with a genie, a spirit released from bottled earth to infinite air, but, rather, a person endowed with given, if extraordinary, powers. Geniuses come in all styles, good or evil, Haydn to Hitler.

In classic academic opera-house dancing, which was his empire, he never claimed to be more than a reassembler, inverter, or extender. This positioning was neither reformation, distortion, nor replacement. His deep and oft-repeated generous obligation and respect for predecessors —Lev Ivanov, Marius Petipa in particular, but also Mikhail Fokine and

Kasyan Goleizovsky—continually surprised commentators, who were quick to flatter Balanchine's surprising movement as "revolutionary." Few of these had been familiar with the late Diaghilev repertory or its St. Petersburg ancestry. Also, they rarely estimated his debt to those heavenly powers which blessed his firmest collaborators, Bach, Gluck, Mozart, Tschaikovsky, and Stravinsky. Balanchine's belief was akin to Søren Kierkegaard's: Morality is not religious life, but only a prelude to it.

III

From his baptism in infancy, Balanchine's sensuous and visual impressions were stimulated by celebration of saints, their feats and festivals. Icons, and the music and incense that wafted about the altar screen, furnished ideas that still resounded when he came to map movements for theatrical action. His uncle, the Archbishop of Georgian Tbilisi, celebrated the Eucharist in vestments of purple and heavy gold. His nephew was given small objects to bless. The boy played at priest, cherishing the precious little relics he'd been handed as sacred toys. The annual remembrance of his own birth and origins, celebrated on the feast day of his patron, St. George of Lydda, were convocations of friends and colleagues, tasting memorable food he cooked, drinking wines he prized. Dependence on hierarchies of protectors—sacred and profane, mythical or historic—was his comfort.

It may be useful to sketch the poetics in theology that irradiated his faith, since these were transmitted to the secular rites he arranged. This is manifest in distinctions between forms of belief in the Christianity of the West, centered on Rome, and that of Eastern, Greek, or subsequently Slavic Orthodoxy embodied in the Second Rome, Constantine's capital which had become Byzantium. In 988 A.D., in Kiev, Prince Vladimir, whose name like the title of Christ means "Ruler of the World," had his people baptized; he established the Church and its institutions. Kiev became the fount of that philosophy of imperial angelism which was incarnate in the flesh and motion of Balanchine's invention.

He was something of an amateur theologian, as were his friends Wystan Auden, J. Robert Oppenheimer, and Igor Stravinsky. To Auden, the anatomies of various theologies were his form of chess. To Oppenheimer, as perhaps to Galileo and Newton, theological formulae measured the rhythm of the random. To Balanchine, concepts or images of the Divine, even cant uses of "divine" as a shibboleth of quality

("My dear, she danced *divinely!*"), had their daily resonance. "Divine" is from *divus*, Latin "of, or pertaining to God (or, a god); given by, or proceeding from God; having the sanction of, or inspired by, God."

His most quoted apothegm was: "to make audiences *see* music and *hear* dancing." St. Paul has it: "Eye hath not seen, nor ear heard, neither have entered into the heart of man, the things which God hath prepared for them that love him." Shakespeare has Nick Bottom, the Warwickshire weaver, fondle his born-again ears, no longer those of a fantastical ass, trying to make sense of a midsummer night's dream, from which he has emerged as a man, not a beast. The peasant reverses Gospel: "The eye of man hath not heard, the ear of man hath not seen, man's hand is not able to taste, his tongue to conceive, nor his heart to report what my dream was."

Balanchine was sometimes amused to contrast notions of good and bad, virtue and vice, grace and sin, distinguishing between his Eastern and our Western orthodoxies. Byzantine icons glossing Holy Script, the mural masters of Hagia Sophia (Holy Wisdom, not St. Sophia), Hosios Lukas (St. Luke in Phocis), and El Greco's Cretan teachers all depict Lucifer—Son of the Morning, Fire-Bringer, soul of free choice and ultimate possibility—not as a fiend but as an angel. In the West, personifications of d'Evil, Father of Lies, Lord of the Flies, Old Nick, Auld Reekie, Foul Fiend, Satan (Shaitan), looked bad and smelled worse. From pre-Christian to late medieval models, devils were imagined as rough humanoid bipeds bestially deformed, horned, with goat's shanks, cloven hooves, spiked tails, and hairy anuses that witches kissed. In contrast, Greek Orthodoxy's knowledge and fear of hell does not argue the simple matter of right and white against black and wrong. So crass an opposition, so low a common denominator, is not existentially exclusive. It is not the deformation or denial of grace that must be considered but the recognition of an equation of right *and* wrong. This is not "either/or," an unenforceable law, but "both/and," a realistic choice. Suffering—education by the consciousness of permanent evil, and of those powers that educate one beyond the capacity of mere self—in the cosmos as in heaven frees the angelic choir.

The Byzantine Lucifer, Prince of Darkness, was to be seen in his glorious mystical uniform identical with his perfect sinless siblings, Gabriel, Michael, Raphael, Uriel, but with one drastic difference. All these last displayed lustrous peacock wings, were robed in gold, haloed in jewels. Fair-haired, brightly complected, the lot. But the hands, face, and feet of the Evil One were black. Transparency blessed the good angels; opacity cursed the bad. All but Satan were clear as crystal. De-

nied by density, impervious to light, he was deprived of the sun of Godhead. His was permanent denial, negation of Source, of the Logos. Willful incapacity to admit the difference between light and darkness, obsessive preference for personal difference in self-serving isolation, proclaimed the triumph of the self. This dark angel and his myriad progeny set themselves against the Father and his apostolic succession, removed from any deselfed communion and, ultimately, in their selfishness, from fruitful service to their fellow men. This angel of night and darkness could not be penetrated by the mercy of grace. But black as he might be, he was still an angel. Today he might stand for the romantically rebellious solipsist, the unreckoning challenger of historicity, prince and demon of every narcissist aesthete, patron of self-devoted artists wherever they flourish.

IV

When Balanchine spoke of angels, as he often did, and of his dancers as angels, he intended confidence in an angelic system that governed the deployment of a corps de ballet. As was common gossip, he imagined at one time that in this mortal dispensation, he had actually "married an angel" in the flesh and had set dances on this third consort. All through his long life, he contrived to encounter these supernal beings or, rather, their corporal embodiments, whose habitual flights he made soar into steps less ordinary than heavenly.

Angels were enlisted in a category that commonly registers demons. Intermediate between gods and mortals, they could be hostile or compassionate. There were Egyptian, Assyrian, and Hebrew winged figures long before Christian eras, personifying and revealing multiple aspects of the divine cosmos. Air, wind, thunder, and lightning proclaimed their power. Gentle breezes and stupendous cyclones were their fingers. Hosts of angels chanted music of the spheres. Good and bad angels were protectors, guides, tempters, and betrayers of babes born sinless, but each with a God-granted choice. And there were dangers for the over-innocent in undue emphasis on their assigned dominion.

"Angel" in Hebrew or Greek means "messenger," one sent, and not necessarily with good tidings. In Christian theology, East or West, angels apply to priests, prophets, and messiahs dispatched by the Godhead. They are spiritual essences "created by God before the heavens and all material things." Black angels fell to devildom, since they were made free to indulge in "desire of absolute dominion over created things, in hatred of any rivalry or subjection." Their sin and our curse is not simple

vanity, but blind pride; in modern dance, this is an incapacity to learn or accept what tradition teaches, the amateur's boastful proposing of an alternate language that its self delimits, a personal idiom legible for no longer than its inventor's existence.

In the Revelation of St. John the Divine, it is written that he prostrated himself before an angel who'd been sent to humble him. John's automatic reverence showed mindless dependence and lazy irresponsibility. The angel bid him rise: "Seest thou do it not, for I am also thy fellow-servant . . . Adore not me, but God." Balanchine believed that he, as well as his dancers, were in constant service—not to any individual ambition, but to the principle of a general humane alliance and need. He had his demonic advisors who helped him in his service of propelling bipeds forward across the stage floors of the world in a shared conquest of earth and air. In this process, often accompanied by "heavenly" music, dancers appear as messengers of fair weather, occasional safeguards from streets outside swarming with chaos, anarchy, and despair.

<div align="center">V</div>

Balanchine's method of instruction was twofold. First came daily class for his company. This might be called "practice," but in reality it was incessant reiteration toward technical refinement. In this endless process, mind and matter were anatomized. He might allow, in tones of cool disparagement, that the only thing students could learn in seven years of academic training was to recognize the difference between correctness of execution and the intensity achieved by stage performance. The scale of the school's annual workshop-demonstration—a program rehearsed during the entire school year in preparation for three open viewings—which marks the advance of students from a lower to a higher division, was tiny, compared to the stress and pressure of working in the company's huge repertory, on a big stage, before a critical public.

Promising aspirants who are marked for eventual soloist standing often disappoint teachers, parents, and, worst of all, themselves. Cute kittens turn into scraggly cats. Children of promise—who had been cushioned by strict repetition under secure conditions, daily, monthly, yearly—when released to the vulnerability of fuller responsibility, may collapse or, more trying, hit a median level of blocked progress with little hope of more capacity. They fade into a dim if useful support, a modest service, in which a passive or resentful handful may find some satisfaction. The life and schooling of professional dancers have their

negative aspects; these Balanchine never concealed. He realized that as much as half the force and efficiency of a supporting corps is fueled as much by resentment as by ambition. Fury at failure to advance or achieve a desired status is not negligible as a source of negative energy. Balanchine calibrated dancers also for their spirit. Some of the lower order of angels are able to accommodate themselves to their assigned rank; some abdicate while still able to perform; others abandon hope at some crisis in a dubious career. Balanchine could be polite enough; he seldom wasted optimal opinion. "Damn braces," said Blake. "Bless relaxes." Willfulness is the curse of children set on stardom.

Modern and now post-modern dancers convince themselves and their annotators that minimal motion is as interesting to watch as to perform, at least to cult or coterie audiences in minimal spaces, clubs for companionship rather than frames for absolute skill. Minimal movement exploits a token idiom of natural motion: walk, turn, hop, run. Also, there is free-fall to the floor plus rolling and writhing. But angels don't jerk or twitch, except as irony or accent: they seem to swim or fly. The domain of ballet dancers is not earth but air. Long, strenuous preparation aims to allow them to defy the pull of floors, releases them from gravity toward the apparently impossible. Academic dancers are trained to leap, as well as to appear to leap, as high as Olympic record breakers. Theirs is an academy of physical, visible magic. Acrobatics are supranormal, or maximal. Acrobats are not walkers, joggers, hoppers, or bores. Their effects are not minimal but angelic.

Angels are androgyne, lacking heavy bosoms and buttocks. Portraits of angels in mural or mosaic have slight physiognomical distinction one from another. There is a blessed lack of "personality" in their stance against the skies. But this aerial or ethereal positioning grants them a special grace or magic in accepted service. Ballerinas are kin to those mythic Amazons who sliced off a breast to shoot arrows the more efficiently. The criterion of professional owns not only a particular psychic tempering, but also peculiar anatomical configuration. Balanchine's standard controlled his company. The few deliberately outstanding exceptions in height or style proved his general rule. His corps was and is a band of brothers and sisters; maybe it is no accident that it contains so many twins and siblings. He would say, of those he could or would not accept, "She (or he) doesn't *look* like a dancer."

Those candidates who anatomically and temperamentally possessed the qualities that Balanchine required were ordained by methods that dissidents found demeaning or deforming. These methods could be taken as frustrating adolescents at the very moment of their incipient

expansion. But liberal educators seldom realize that "success" or "happiness" lies neither in self-satisfaction, in self-indulgence, nor in that unfocussed hedonism which too many young people believe is their franchise, obligation, and destiny. Their precious "personalities" are but a bundle of chance preferences, since as yet they have had only the opportunity, but hardly the ability, to analyze received data, *to think*.

The ballet dancer's mode of existence may seem to outsiders as circumscribed as that of convent or cloister. More than accepting rude discipline, professionals must endure not only unappeasable mental anxiety like everyone else, but also from their bodies, brittleness, strain, and fatigue. The hazards of a snapped Achilles tendon, bad sprains, slipped disks, the anguish and boredom of measureless recuperation, the slow and dubious resumption of practice and performances—these are taxes every good dancer must pay. In this process, by the conscious use and comprehension of suffering, the dancer begins to perceive the essence of the Nature of Existence, of Being, of serving one's art and craft, of one's true nature and destiny. It is a stringent education, but when we see a great dancer onstage, performing with full power, we are inspecting a very developed human being, one who knows more about self than any psychiatrist can suggest. Seamless luck in avoiding injury doesn't exist here any more than in any of the games for which people applaud winners.

Many modern therapies, with current spiritual scenarios, preach condign avoidance of suffering as if it were anathema, the unearned deserts of mindless fate. Mrs. Eddy's Christian Science swears that the existence of suffering is purely imaginary. Placebos for extenuation or avoidance come a dime a dozen, or as bargains for a fifty-minute hour. Since suffering is indeed real and unavoidable, analysts, lay or legitimate, proffer their mesmeric recipes which have become pandemic since Freud met Charcot. Balanchine offered no cure, but work in which the self-wounded artist could best cure self. His requirements were really extreme, corresponding to real extremity.

VI

Three musicians whom Balanchine most preferred as partners were, in the familiar sense, profoundly "religious." Each was a communicant Christian according to the frame of his historical perspective. The fabric of their imaginative process was coined from Christian Gospel. The opening *Preghiera* in *Mozartiana*, Tschaikovsky's homage to a predecessor, danced with such total consecration by Suzanne Farrell, is a rescript

of Mozart's *Ave Verum Corpus* ("Hail the True Body of Our Lord"). It was Mozart's own *Requiem Mass* which the ballet master ordered for his memorial.

When the Tschaikovsky Festival of 1981 closed with a setting of the fourth movement (*Adagio Lamentoso*) of his *Sixth Symphony*, the *Pathétique*, which contains a quotation from the Orthodox Service for the Dead, Balanchine made a flock of a dozen angels, their tall, gilt wings, stiff as in an icon, flow onstage. They stood immobile, witnesses giving testimony to a martyrdom. A cruciform composition of prostrate, despairing monks made a great Cross, centering the scene with the breathing metaphor of a magnificent artist's trial and judgment. Condemned by a hypocritical society and its legal cabal, Tschaikovsky, self-slain, had taken his poisoned chalice. At the end of the ballet, a small boy in a white shift, bearing a single lit taper, drew a wide world into the dancers' concentrated space. When he blew the tiny flame out, the real presence of evil burned black. Absolute silence after the curtain fell was instinctive recognition more stunning in its delayed and silent shock than thousands of applauding hands.

For the climactic finale of the Stravinsky Festival of 1972, there was no choice but to crown it with his *Symphony of Psalms*, a sole, appropriate *amen*. But unlike some younger, less aware choreographers, Balanchine was not quick to compete with the choir. Instead, his dancers, in ordinary practice dress, sat at ease on the stage floor, in eager attention, framing the musicians. Now they were "hearing," not "dancing." There was no waste or excess in adorning or "interpreting" sonorities which commanded their unique autonomy. This ballet master knew there is music superior to any visual gloss.

It is often reiterated that Balanchine was an "inspired" maker. He was indeed infinitely capable of drawing from the traditional lexicon of steps, as if he breathed or derived from it a fresh range of motion. It is difficult for many to comprehend the extraordinary richness of discrete steps in their academic configuration which make up the idiom which he handled, but the easiest comparison is a parallel in musical notation, its keys and combinations. Often, a surprising or abrupt sequence of steps infused his dancers' bodies easily and inevitably as a refreshment of systole and diastole. This exceptional talent was commonly recognized as "God-given," but, since the deity granting it was seldom acknowledged, it was rarely admitted that the artist inspired thought he owed something to his Creator.

Balanchine reported to W. McNeil Lowry, that on his appointment as the last ballet master to Diaghilev, at the age of twenty, he was

brought to Florence in order to learn to look at pictures. In Russia there had been little time or opportunity for such instruction. Lowry's tape recording reads:

> . . . I couldn't understand why it [painting] was good at first, but he [Diaghilev] told me: "Now you stare for hours; we're going to have lunch and when we come back you'll still be there," in some chapel where Perugino was. So I stared and stared and stared, and they came back and I said: "No. I don't know what's good about it." Later on, I went myself a hundred times. Then I realized how beautiful it is: the sky so pale blue and the way the faces . . .
>
> And from then on I somehow started to see Raphael and how beautiful it is and then I found Mantegna and then Caravaggio and finally I realized how beautiful is Piero della Francesca. Also I was probably a lot influenced by the Church, or *our* [Orthodox] Church, the enormous cathedrals, and by our clergy, the way they were dressed, you know; and they also have a black clergy, those important ones that become patriarchs [archimandrites] and wear black . . .
>
> So that also to me was God. Not that it's "God Invisible." I don't know what that is. God is this wonderful dress you see. Even now, always, I have to say I couldn't just think of God in some abstract way, to connect with Him just by spirit, by mind. You have to be really mystic to sit down and meditate, to worm down in yourself. But I can't do that. As they say, my work is with what I see, with moving, with making ballets. So too with God—He is real, before me. Through Christ I know how God looks, I know His face, I know His beard, and I know how He'll talk, and I know that in the end we'll go to God. You see, that's how I believe, and I believe so fantastic . . .

Name it *God* or *Order*, what conspired to "inspire" Balanchine to construct stage movement, as well as what moves his inheritors, is neither capricious improvisation nor waste motion. It derives from an energetic source that permits it to fulfill circumscribed stage space for more than one "inspired" occasion. He made dance works strong enough to bear repetition, and by performers other than their own inspirers. His inestimable service was an ordering of active behavior as a reflection of overall orderliness, as well as its negative aspect in dislocation and disorder. There are his caustic violations of the traditional canon—inverted feet, angular arms, jagged fingers, "ungraceful" torsion, "ugly" attitudes. His was and is a constant demonstration of outrageous liberties in choice within the large, encompassing lectionary from which he had the wit and skill to draw.

Even today, we have no more viable a word for "divinity" than its

opposite in "anarchy" or the eschatological "absurd." Balanchine's catalogue is a book of orderly rites, psalms, hymns. These were confidently conceived and constructed by and to order. Many were produced in answer to current, pressing needs. Mandatory was his supply of "opening," "middle," and "closing" ballets. Rousing applause machines were not to be wasted by being set first on a program; they were to be saved for a culminating finale. Different works, after their introduction, could in time be shifted about; the placement was frequently determined by requirements in setting up complicated scenery, so that intermissions might not seem too long.

Season after season, works were on order, like fresh skirts, shirts, ties, and trousers, to tempt the new, while satisfying old, subscribers, to ensure in advance fiscal security and practical continuity. Ballets were often brought into being by response to immediate popular taste or fashion, with various results as to box-office success or lasting acceptance. A rule of thumb indicated one out of three might remain in the repertory after three seasons; some, failing at first, had more luck in revival. Like seeds of the dandelion, many must be blown about to assure a central harvest. It was not only the challenge or curiosity in innovation, or even in the commissioning or resuscitation of powerful or surprising composers: Ives, Webern, Sousa, Hindemith, Gershwin. Balanchine set steps "*sur mesure et par commande*," like a master cabinetmaker, tailor, or cook.

Although he could recognize his own sins down to their least fraction, he rarely complained of subjective blockage, or restraint in energy due to personal dismay or private pain. There were never any arguments over contracts; with his own succession of companies there was hardly even a verbal agreement. Confidence was mutual, confirmed by silence on irrelevant legalities. There were few complaints about funding withheld, few interviews granted to "explain" or justify his intentions. He made no protests, sent no corrections to critics, staged no tantrum exits. When he quit the Metropolitan Opera, in which his company survived three trying years, it was done overnight, with small explanation. But when he discovered that the orchestra pit at the New York State Theater in Lincoln Center, ostensibly designed for him, could contain enough musicians of service only to Broadway, he called in jackhammers to carve out a decent space. When he refused to dance in Washington's Kennedy Center for three seasons due to the wretched stage floor, it was eventually repaired.

Picturesque, romantic, marketable narcissism, the whole dead mirror of the manipulative persona, was an identifiable enemy, petrified in the

star system, the promotion of flashy performers for richer returns to agents and impresarios. Early on he had estimated the value of critical reportage of dance events. Working journalists pressed by loose thought or the need to put their papers to bed were rarely as assiduous in their observation as sports or science writers. In his early career he had been reviled by the leading critic of Paris for the insolence and degeneracy noted in his choreography for Stravinsky's *Apollon Musagète*, the music of which was equally condemned. Over the years journalists managed to propose both "the Balanchine dancer" and "the Balanchine ballet" without much analysis of the diversity in the choice of his dancers or in the variety of what they danced.

Along with translations of Shakespeare, Dante, Goethe, and Schiller, Pushkin was learned by heart in the Tsar's dancing school, following whole chapters from New and Old Testaments. In 1950, when Balanchine revived *Prodigal Son*, his last ballet surviving from the Diaghilev repertory (save *Apollon*), produced originally with Prokofiev and Rouault, Wystan Auden was taken backstage at the old City Center of Music and Drama on West Fifty-fifth Street. The poet spoke as a devoted biblical student and professional man of theater. In the ballet's last scene, the austere father figure, recalling Jehovah as imagined by William Blake, stood stock-still, unbending, impassive. His wayward son, now abject in shame, traversed the wide stage floor on his knees. Dancers who assumed the role padded their knees against splinters. Auden complained that the Father should not have remained rigid, but with Christian compassion, might have advanced at least a step, in some sign of pardon. Auden might have quoted Luke: "I will arise and go to my father, and will say unto him, Father, I have sinned against heaven, and before thee, and am no more worthy to be called thy son: make me as one of thy hired servants. And he arose, and came to his father. But when he was yet a great way off, his father saw him, and had compassion, and ran, and fell on his neck, and kissed him."

The choreographer disagreed. He made his own point, altering Scripture for his own didactic purposes. Christ, first of all, was a Jew, raised on the Pentateuch, which included Deuteronomy and Leviticus. The parable embodied an older Testament's tribal ethic. To be sure, the penitent sinner would be ultimately forgiven; and in the staging the boy climbs up into the father's strong arms. A cape covers the boy's shame, making his vulnerability dramatically clear. And Balanchine slyly justified his tampering with the text. Was not the generous gesture an early patristic interpolation, sweetening the rabbinical rigor in favor of propaganda for the new faith?

What was inferred was an indication of Balanchine's metaphysic. Only through acceptance, realization, and use of the responsible self, even though it might mean a denial of mercy or support, can vain, energetic youth be brought to Abraham's bosom. An Anglican poet spoke by a new, but a Russian Orthodox by an older, wisdom. This was hardly an eye for an eye, a tooth for a tooth, but as ballet master, Balanchine seldom shirked diagnosis. Unaccompanied by any drastic final judgment, his close inspection was, in its immediacy, severe. Only those in whom he had no interest or expectation failed to feel his scalpel.

In promoting dancers from the rank of corps member to soloist or principal, sometimes he seemed slow to act. In an elite world of acrobatic virtuosity, pure justice is accompanied by few explanations and no apologies. Following Ring Lardner's omnivorous advice, the choreographer's advice often reduced itself to "'Shut up,' he explained." In the end, there was no mitigation and not much further recourse. Sometimes there were wordless estimations, accompanied by an unmistakable facial or physical expression, which were his analyses of all the factors: corporal, psychological, moral. While he could cherish Suzanne Farrell as "my Stradivarius," such breezy, wholesale, entire-encompassing tolerance was in fact a brutal, unsentimental computerization.

In this conservatively economical survey he remembered the general self-indulgence, lethargy, and irresponsibility which are the inalienable rights of American parents and their spoiled progeny. When one mother asked him, in the tones of a Roman matron: "What are you going to do for my noble boy?" (one already half-castrated), Balanchine answered: "Nothing. Perhaps, only perhaps, he can do some little thing for himself." In morning class, a brilliantly promising male of seventeen, on the verge of entering the company, bit his lip savagely, in evident disgust or despair at his inability to make his muscles obey what his will demanded. His grimace of self-contempt seemed excessive. Temporary failure was inconvenience, not tragedy. Instead of reassurance, Balanchine snapped at the boy: "It's you who chose to be a dancer. I didn't choose for you."

As professor of an highly inflected language, dependent on a pyramidal structure of physical exercises resulting in the subtlest visual refinement, his precise teaching derived from illustration, not with words but with his own body's continual demonstration. Some of his students would doubt that Balanchine had ever been much of a brilliant performer himself. They spoke of his early tuberculosis and lack of a lung, the time and energy required to compose his constant inventions. He stopped dancing in the early thirties, but photographs from the twenties show him not only as Kastchei, the demon-wizard of *Firebird*, and the

Old Showman in *Petrouchka*, but as the Spirit in *Le Spectre de la Rose* and Prince Charming in *Aurora's Wedding* (in which role Diaghilev would never have let him appear, since he would have followed Pierre Vladimiroff, of the great 1921 revival).

Anyone who watched Balanchine give class, whatever his lost physical efficiency may have been in the early eighties, knew they were seeing a kind of analyzed legible movement, as if it were cast in bronze or cut in marble. He had contempt for those retired dancers who taught complacently, even seated in class, with no real talent for the transmission of their language, whatever their past fame in performance, or for those who perfunctorily, dramatizing their own particular style, "talked a good class," showing hungry students what they wished to be told. Speed in footwork, his famous "elephant-trunk" metaphor for pointe (supple but strong), steel clarity of profile, perfect balance in partnering, the consideration needed to support another's weight in motion, don't come easily or quickly.

Yet he could, with no trouble, forgive a kind of behavior, apparently disorderly, which hid hints of latent energy. This might well indicate a commitment to the profession stronger than the ordinary. There could be abrupt seizures of demonic hysteria, masking nervous insecurity or fear of failure, actually only symptoms of excess energy. One promising girl, midway in school, in a fit of resentful frustration, tossed off all her clothes to parade in the corridor. Of course, she got herself suspended for that term. What else could one do? On the other hand, Balanchine was delighted, since he saw she had the temperament of a first dancer, which she shortly became. Ah, but what if everyone behaved like that? No danger.

And his consistency was inconsistence. In his company there would always be use for those dancers who defied familiar facile formulae that less masterful directors might find basic requirements. Some might, at best, be thought of as mascots or pets; but rather, they were more like exotic flavorings—peppercorns, odd mustards, horseradish, marjoram, pistachio—flavorings that dressed his salad bowls. His choices could seem flagrant eccentricity, the flouting of his own declared criteria. But these were decisions based on long experience in which few others were able to share, and from which there was no recourse.

VII

In Moscow, between October 16 and 22, 1972, Balanchine was interviewed by "Nedelia," the weekly "cultural" supplement of the newspaper *Izvestia*. Headed "A Conversational Pas de Trois," it comprised Balanchine, the choreographer Jerome Robbins, and Yuri Grigorovich, chief ballet master of the Bolshoi Ballet Company since 1964, who was considered a relatively progressive artist. It was the New York City Ballet's second tour of the Soviet Union; Balanchine was now more or less accepted as a returned prodigal son, native, however errant. Grigorovich expressed admiration for the technical, or more honestly, the mechanical virtues of *Concerto Barocco* and Bizet's *Symphony in C*, while regretting the American disdain of narrative mimicry, scenic investiture, the full panoply of ballet tradition in opera houses. To him, and indeed to many of his French and English counterparts, Balanchine seemed puritanical, rather perversely wasting so much in the famous troika of dance, décor, and music, summarily suspending them—and by one working in so affluent a nation as the United States. Balanchine consistently reaffirmed the capital autonomy of dance *steps*, the stuff of choreography. The laureate of the Lenin Prize responded:

GRIGOROVICH: Since we are speaking of some kind of affirmation, I affirm the art of representation in its most spectacular brilliance of which theater is capable. I don't know to what point, personally, I am successful, but I affirm ballet as a great theatrical art, with a complex and active dramatic content, expressed in dance by the accompaniment of painting helping to express this by scenery, with especially commissioned music, and of course with the pantomime of actor-dancers. It is possible to stage a ballet without scenery or costumes by dressing dancers merely in practice clothes, but why limit yourself? It is bad, naturally, if all these theatrical components do not help in expressing the idea which inspires you. But if they do, is it not splendid?

BALANCHINE: What do I affirm or reject? I reject nothing. Why should I? I am not affirming anything either.

'NEDELIA': But you do express yourself?

BALANCHINE: I am not doing anything in particular. I simply dance. Why must everything be defined by words? When you place flowers on a table, are you affirming or denying or disproving anything? You like flowers because they are beautiful. Well, I like flowers, too. I plant them without considering them articulately. I don't have a "logical" mind, just

three-dimensional plasticity. I am no physicist, no mathematician, no botanist. I know nothing about anything. I just see and hear.

GRIGOROVICH: A flower *is* beautiful. But it is Nature, not Art. A flower affirms nothing, but the man who plants it affirms both the flower and its beauty. And how about Japanese flower arrangement? Is this not Art?

BALANCHINE: Of course I have a logic. But it is the logic of movement. Something is joined together, something else discarded. I am not trying to prove anything. That is, trying to prove something quite other than the fact of dancing. I only wish to prove the dance by dancing. I want to say: "If you should happen to like it, here they are: dancers dancing. They dance for the pleasure of it, because they wish to." Don't other people dance? All of Georgia [his ancestral home] dances! And these people dance for delight without hoping or wishing to prove anything.

GRIGOROVICH: But there is a difference between "just dancing" and ballet. Folk and social dancing are primarily for oneself. Ballet is dancing for an audience. Dancing just for fun is an emotion, whereas ballet is an art which transforms emotion into thought and unites them.

BALANCHINE: I believe in the dance as an independent category, as something that really exists in itself and by itself. However, this may be an unreal or inaccurate metaphysical category, something immaterial, perhaps indefinable.

'NEDELIA': But you said yourself [at the start of the interview] that your ballets were not "abstractions," that live people performed them . . .

BALANCHINE: Yes. They convey the sense of the dance to the spectator, but the dance also exists without spectators!

GRIGOROVICH: Pray, in what form?

BALANCHINE: In the form in which it comes to me; in the form in which I set it out.

VIII

The magnificent pictorial tradition of Byzantine-Slavic Orthodoxy is rich in its strongly mysterious treasury of sacred imagery, in mural painting and portable panels. Not long ago, when these votive works began to be collected in the West, at least with examples on a less-than-monumental scale, icons were estimated as hardly more than native artifacts, naive "folk art." Similarly, African fetish objects and ritual masks, called into being for purely religious use, were set down as evidence of "primitive" superstition, although prized for plastic or aesthetic quali-

ties. Although African, Oceanic, and pre-Columbian art are now widely admired and expensively mounted, hardly a Western museum hangs important images by Greek, Russian, Serbian, or Cretan painters in the line of Andrei Rublev or the School of Vladimir-Suzdal. However, some scholars of broad curiosity are not slow to place such panels alongside the finest temperas of the early Tuscans and Umbrians. We often ignore the fact that these artists were working in the same belief as Giotto, Masaccio, and Fra Angelico.

The anonymous spirit and service of subsequent icon painters required that any individual or idiosyncratic expression of image or idea must be held to a minimum, toward greater emphasis on the glory of God. The Fathers of Byzantine Orthodoxy, defending their art against iconoclast puritans, swore: "We do *not* worship icons; we know that the veneration accorded the image ascends to the Prototype." It was not the stuff crafted, painted, gilded, armored in precious metals with such devotion which was adored, but rather the incarnate Idea.

Balanchine's ballets can be read as icons for the laity, should we grant dancers attributes of earthly angels. These have sworn to disavow hedonism in a calling which demands transcendence of worldliness and possessiveness, an abjuration and abandonment of elementary self-indulgence. We can even discover in their aura an animal innocence as one aspect of the Lamb of God which takes away the sins of this world, for they sacrifice much enjoyment in ordinary fun and games of their fellows. They are schooled to serve paradigms of order—at least for the temporal duration of their performing—which, if well done, seem momentarily to give their audience something approaching "peace of mind."

Over the last half-century, perhaps for the first time since Euripides, theaters, even more than museums of precious artifacts, have taken the place of temples. Ballet, opera, the classic dramatic repertory offer secular rites in which a communion exists between lay hierophants and a congregated public. There is also a vital distinction in the architectural planning of places of worship, West and East. Roman cathedrals descended from basilican law courts of the late Empire. The altar, focus of faith, was always in view. In Eastern Orthodoxy, the icon screen separates the Holy of Holies from the people, who are not seated in pews, but always stand. The officiating priest passes in and out of the sacred golden portals, disappearing and reappearing, a sign of that intermittent mystery which clouds any absolute or final answer. We are led to take much faith as fact. More is withheld in our incapacity to encompass a totality of reality.

Our modern theater assumes the frame for an atmosphere of ritual. We sit in big, multibalconied rooms, brightly lit, in expectation of magic. Lights dim in the auditorium and flare in footlights. Silence, then the breath of strings, woodwinds, brass. A curtain rises, launching a celebration. If the measures are properly performed with force and dignity, which is their due, a shard of general order is revealed. A charge of electrified sympathy suffuses a public which becomes less passive. Released applause at the end signals the sight and sound of an angelic order. What has been seen and absorbed is commonly agreed to have been of the "Divine."

Notes on the Photographs

50. 1904. Georgi, born in St. Petersburg on January 22, 1904, son of Meliton and Maria Balanchivadze, with his wet nurse. His father, a distinguished musician and composer, a collector of Georgian folk music, was known as "the Georgian Glinka." *Photo: R. Charles. Courtesy, Andrei Balanchivadze.*

51. 1913. In student uniform, with his brother, the composer Andrei, on their entry to the Imperial Theatre School—after the Revolution it was known as the Petrograd Theatre School. Apart from ballet instruction, Balanchine, right, also studied music. Later he studied at Petrograd Conservatory of Music. *Courtesy, Andrei Balanchivadze.*

52. 1923. Partnering Tamara Geva in a pas de deux, ÉTUDE, set to music by Alexander Scriabin. Composed for a company he organized in Russia, the Young Ballet, this also served, probably, as an audition piece for Serge Diaghilev in Paris in the autumn of 1924. *Courtesy, Karin von Aroldingen.*

53. 1926. On vacation, in a Venetian vaporetto. He had left the Soviet Union in 1924 with a small group known as Principal Dancers of the Russian State Ballet. Later that year the group joined Diaghilev's Ballets Russes. It was Diaghilev who changed the name Georgi Balanchivadze to Georges Balanchine. *Photo: Boris Kochno. Courtesy, Boris Kochno.*

54. 1925. Partnering Vera Nemtchinova in the pas de deux from *Aurora's Wedding*, based on the third act of *The Sleeping Beauty*. This was salvaged from Diaghilev's 1921 production, a monumental financial failure, of the Tschaikovsky/Petipa work. *Collection of Anton Dolin. Courtesy, Theatre Museum, Victoria and Albert Museum.*

55. 1926. As Kastchei, the evil Magician in *Firebird*, with Lydia Lopokova, during the short London season of the Ballets Russes at the

Lyceum Theatre. *Photo: Daily Sketch, London. Courtesy, Theatre Museum, Victoria and Albert Museum.*

56–57. 1925. Monte Carlo. Waiting for the end of a rehearsal of Léonide Massine's *Les Matelots*, with dancers in Henri Matisse's costumes for LE CHANT DU ROSSIGNOL, score by Igor Stravinsky, Balanchine's first choreography for performance in the regular season of Diaghilev's Ballets Russes. *Photo: Harlingue-Viollet. Courtesy, H. Roger Viollet.*

58. 1929. With Felia Doubrovska in LE BAL, Balanchine's next to last ballet for Diaghilev—PRODIGAL SON was the last—to a score by Vittorio Rieti, with set and costumes by Giorgio de Chirico. *Courtesy, Theatre Museum, Victoria and Albert Museum.*

59. 1929. With Lydia Lopokova and Anton Dolin in the "Tartar" ballet JEALOUSY, to music by Modest Moussorgsky, for the first English feature-length sound film, DARK RED ROSES. During the production of this film the dancers received news of Diaghilev's death in Venice on August 19. *Courtesy, Milo Keynes.*

60. 1930. With Ulla Poulsen in LE SPECTRE DE LA ROSE. Balanchine staged Mikhail Fokine's ballet for a charity performance while he was in Copenhagen as guest ballet master of the Royal Danish Ballet. While there, he restaged ballets by Massine and Fokine, and made his own version of Richard Strauss's LEGEND OF JOSEPH, which had originally been set for Diaghilev by Fokine. He also staged his own APOLLON MUSAGÈTE with Leif Ørnberg. *Photo: Palfot, Copenhagen. Courtesy, Politikens Pressefoto.*

61. 1932. With Tamara Toumanova (on chair) and Natalie Strakhova in COTILLON, to music by Emmanuel Chabrier. Balanchine danced the preview performance, in a role taken later by David Lichine. René Blum had invited Balanchine to be ballet master of a new company, Les Ballets Russes de Monte-Carlo. The two major ballets he made for this company were COTILLON and LA CONCURRENCE. Balanchine left the company over policy disagreements and in 1933 formed Les Ballets 1933 with Boris Kochno in Paris. That company was shortlived, but it was in this year that Lincoln Kirstein invited Balanchine to establish a school and company in the United States. *Photo: Raoul Barba. Courtesy, Tamara Toumanova.*

62. 1934. The first studio portrait taken in America. Until his death in 1958, Lynes documented Balanchine's person and work. *Photo: George Platt Lynes. Courtesy, Lincoln Kirstein.*

63. 1937. With Gisella Caccialanza, the goddaughter of the great teacher and mime Enrico Cecchetti, and Daphne Vane, rehearsing ballet sequences for the film GOLDWYN FOLLIES. This featured dancers of the American Ballet, the company formed with Lincoln Kirstein and Edward Warburg in late 1934. *Photo: Coburn. Courtesy, The Museum of Modern Art/Film Stills Archive.*

64. 1938. With students Charles Laskey and Holly Howard, teaching adagio (partnering) class at the School of American Ballet, whose first studios were at 637 Madison Avenue. *Photo: RKO Pathé News. Courtesy, Dance Collection, The New York Public Library.*

65. 1938. With Annabelle Lyon. School of American Ballet. *Photo: RKO Pathé News. Courtesy, Dance Collection, The New York Public Library.*

66. 1937. Left to right, Edward Warburg, Hortense Kahrklin, Leda Anchutina, Igor Stravinsky, Ariel Lang [Helen Leitch], Annabelle Lyon, Balanchine; with William Dollar (back to camera). A publicity photograph taken for the first Stravinsky Festival given by the American Ballet, at that time the resident ballet company of the Metropolitan Opera, with the cast and creators of CARD PARTY (JEU DE CARTES). Given with APOLLON MUSAGÈTE and LE BAISER DE LA FÉE at the Metropolitan Opera House, April 27 and 28, 1937. *Photo: Maharadze.*

67. 1937. With Ariel Lang [Helen Leitch]. Adjusting an Irene Sharaff costume, CARD PARTY. *Photo: Alfredo Valente. Courtesy, Dance Collection, The New York Public Library.*

68. 1938. At the piano. *Photo: Walker Evans. Courtesy, Estate of Walker Evans.*

69. 1937. Left to right, Mitzi Green, Richard Rodgers, Edgar Fairchild, Balanchine; with Lorenz Hart (back to camera). At a rehearsal for BABES IN ARMS. This was the second of the four shows Balanchine choreographed for Rodgers and Hart; the others were ON YOUR TOES,

I MARRIED AN ANGEL, and THE BOYS FROM SYRACUSE. *Photo: Lynn Farnol Group. Courtesy, The Rodgers and Hammerstein Theatre Library.*

70. 1937. With Vera Zorina and dancers from the American Ballet. In Hollywood, rehearsing a ballet sequence for GOLDWYN FOLLIES. *Courtesy, United Press International Photo.*

71. 1937. With Vera Zorina, on the set for GOLDWYN FOLLIES. The design for the plaster horse was derived from a painting by Giorgio de Chirico. *Courtesy, The Museum of Modern Art/Film Stills Archive.*

72–73. SERENADE, a ballet to Tschaikovsky's *Serenade for Strings*, the first American work by Balanchine, was originally made for students at the newly founded School of American Ballet, beginning in March 1934. The photograph is of the New York City Ballet production, 1981. *Photo: Paul Kolnik.*

74. 1941. Portrait. *Photo: George Platt Lynes. Courtesy, Dance Collection, The New York Public Library.*

75. 1942. With Modoc, the performing elephant, rehearsing for THE BALLET OF THE ELEPHANTS, to Stravinsky's *Circus Polka*. First performed in New York, April 9, 1942, at Madison Square Garden, by Ringling Brothers and Barnum & Bailey Circus. *Courtesy, United Press International Photo.*

76. 1944. With Alexandra Danilova and Frederic Franklin and dancers of the Ballet Russe de Monte Carlo. Rehearsing DANSES CONCER-TANTES to Stravinsky's score in the City Center rehearsal room. From 1944 to 1946 Balanchine was resident choreographer of the Ballet Russe de Monte Carlo. *Photo: A. F. Sozio. Courtesy, Tanaquil Le Clercq.*

77. 1948. With Maria Tallchief, in costume for the Ballet Russe de Monte Carlo production of LE BAISER DE LA FÉE. *Photo: Irving Penn. Courtesy, VOGUE.*

78. 1948. With children from the School of American Ballet, Edward Villella center foreground. *Photo: George Platt Lynes. Courtesy, Dance Collection, The New York Public Library.*

79. 1948. With Tanaquil Le Clercq and Francisco Moncion, rehearsing

SYMPHONY IN C, score by Georges Bizet, which was first presented at City Center on March 22, 1948, by Ballet Society, a producing organization Balanchine formed with Lincoln Kirstein in 1946. Soon after, Morton Baum, chairman of the Executive Committee of City Center, invited Balanchine and Kirstein to found a permanent resident company under the aegis of City Center of Music and Drama, Inc. *Photo: George Platt Lynes. Courtesy, Dance Collection, The New York Public Library.*

80. 1952. Conducting the New York City Ballet Orchestra for a performance of SYMPHONY IN C. *Courtesy, Dance Collection, The New York Public Library.*

81. 1952. With Tanaquil Le Clercq, in costume for METAMORPHOSES, designed by Barbara Karinska. To music by Paul Hindemith, this was a ballet of insectile life. *Photo: Clifford Coffin. Courtesy, Tanaquil Le Clercq.*

82. 1958. As Herr Drosselmeyer in the first act of THE NUTCRACKER, taken during the rehearsal for the CBS "Playhouse 90" telecast of the complete ballet. Balanchine's version was first produced in 1954, and he made special unannounced appearances in it over the years. *Photo: Fred Fehl.*

83. 1958. With Allegra Kent as Anna in the Kurt Weill/Bertolt Brecht work THE SEVEN DEADLY SINS. Balanchine had staged the first production for his Les Ballets 1933 when Tilly Losch had danced the role of Anna. The singing Anna in both productions was Lotte Lenya. For the 1958 production the English translation was made by W. H. Auden and Chester Kallman, and the designer was Rouben Ter-Arutunian. *Photo: Gordon Parks, LIFE Magazine.*

84. 1953. With Lincoln Kirstein. *Photo: Feingersh-Pix.*

85. 1957. With Igor Stravinsky, discussing the score of AGON. *Photo: Martha Swope.*

86. 1962. Teaching at the School of American Ballet's second home at 2291 Broadway. *Photo: Henri Cartier-Bresson.*

87. 1958. With Arthur Mitchell, rehearsing THE FOUR TEMPERAMENTS. Mitchell, a scholarship student at the School of American Bal-

let, was one of the first blacks to attain eminence as a classical dancer. After the death of Martin Luther King, Jr., he founded the Dance Theatre of Harlem, which has toured all over the world. *Photo: Martha Swope.*

88–89. SYMPHONY IN C, to the Bizet score. This ballet, created for the Paris Opéra Ballet in 1947 and originally titled LE PALAIS DE CRISTAL, was presented with CONCERTO BAROCCO and ORPHEUS at the first performance of the New York City Ballet, October 11, 1948, at City Center. The photograph is of a 1983 New York City Ballet performance. *Photo: Paul Kolnik.*

90. 1958. With Maria Tallchief, rehearsing GOUNOD SYMPHONY. Balanchine spoke of this work as "a garden of dancers," and it was danced before a garden drop by Horace Armistead. *Photo: Martha Swope.*

91. 1963. With Diana Adams and Jacques d'Amboise, rehearsing Stravinsky's MOVEMENTS FOR PIANO AND ORCHESTRA. *Photo: Martha Swope.*

92. 1961. With Mourka, the angel cat of Tanaquil Le Clercq and Balanchine. *Photo: Martha Swope.*

93. 1963. Demonstrating teaching techniques for a Teachers' Seminar at the School of American Ballet, as part of the activities sponsored under a grant from the Ford Foundation. In 1969 the School moved to new quarters at The Juilliard School at Lincoln Center. *Photo: Nancy Lassalle.*

94. 1962. Rehearsing Stravinsky's dance-drama NOAH AND THE FLOOD, which was commissioned for CBS Television. The text was selected by Robert Craft from Biblical and literary sources and the design was by Rouben Ter-Arutunian. *Photo: Ernst Haas.*

95. 1962. Rehearsing NOAH AND THE FLOOD. *Photo: Ernst Haas.*

96. 1962. Rehearsing NOAH AND THE FLOOD. *Photo: Ernst Haas.*

97. 1964. With Edward Villella, rehearsing the male variation in SWAN LAKE. *Photo: Jack Mitchell.*

98. 1965. With Kay Mazzo, rehearsing the "Courante Sicilienne" in DON QUIXOTE. In 1964 the New York City Ballet moved to the New York State Theater at Lincoln Center, and DON QUIXOTE was the first full-length ballet for the new theater. Its elaborate production took advantage of the enlarged facilities. Balanchine performed the role of the Don at its gala preview and on later occasions. *Photo: Gjon Mili.*

99. 1965. Adjusting the headdress worn by Suzanne Farrell, the Dulcinea of DON QUIXOTE, with couturier Barbara Karinska and designer Esteban Francés looking on. *Photo: Martha Swope.*

100. 1965. Rehearsing the first scene of DON QUIXOTE, with small boys who the Don has imagined have emerged from the pages of books on chivalry. *Photo: Gjon Mili.*

101. 1965. With Richard Rapp, who performed the title role of DON QUIXOTE at the premiere. *Photo: Martha Swope.*

102. 1965. With Suzanne Farrell. In 1960 she was in the first group of scholarship students chosen under the auspices of the Ford Foundation Scholarship program. She joined the company in 1961, and the first great role made for her was Dulcinea. *Photo: Gjon Mili.*

103. 1965. As Don Quixote, with Suzanne Farrell as Dulcinea. *Photo: Fred Fehl.*

104–105. SYMPHONY IN THREE MOVEMENTS. The Stravinsky score, commissioned by the New York Philharmonic Society, was written between 1942 and 1945, as a summation of the composer's sentiments about World War II. It was first performed with Balanchine's choreography, conducted by Robert Craft, on the opening program of New York City Ballet's first Stravinsky Festival, June 18, 1972. This photograph is of a 1983 New York City Ballet performance. *Photo: Paul Kolnik.*

106. 1972. With Karin von Aroldingen and Jean-Pierre Bonnefous, rehearsing VIOLIN CONCERTO. The music, Stravinsky's *Concerto in D for violin and orchestra*, was commissioned by Blair Fairchild in 1931 for the violinist Samuel Dushkin. The ballet was first performed on the opening night of the Stravinsky Festival, June 18, 1972, and Joseph Silverstein, first violinist of the Boston Symphony Orchestra, was solo-

ist. The two other principal dancers were Kay Mazzo and Peter Martins. *Photo: Gjon Mili.*

107. 1972. Rehearsing ORPHEUS, revived for the Stravinsky Festival, with the mask of the slain Orpheus. This ballet, commissioned from Stravinsky, was first performed April 28, 1948, at City Center, by Ballet Society. The scenery and costumes were designed by the distinguished Japanese-American sculptor Isamu Noguchi. *Photo: Martha Swope.*

108. 1972. Rehearsing children for CHORAL VARIATIONS ON BACH'S 'VOM HIMMEL HOCH', a work performed once only, on the closing night of the Stravinsky Festival, June 25, 1972. *Photo: Martha Swope.*

109. 1972. With Kay Mazzo and Peter Martins, rehearsing DUO CONCERTANT. *Photo: Martha Swope.*

110. 1970. Rehearsing FIREBIRD. Balanchine made his first version of the Stravinsky work in 1949, with scenery and costumes by Marc Chagall. He revised the ballet completely in 1970, made other changes in 1972 for the Stravinsky Festival, and revised it again in 1980. *Photo: Jack Mitchell.*

111. 1972. With Violette Verdy, Jerome Robbins, and Edward Villella, on the opening night of PULCINELLA, June 23, 1972, as part of the Stravinsky Festival. This was Balanchine's first setting of the Stravinsky score, and the ballet was co-choreographed with Robbins. The scenery and costumes were by one of Balanchine's favorite designers, Eugene Berman. Robbins had joined the New York City Ballet in 1949, and from 1950 to 1959 he served as associate artistic director. He returned to the company in 1969, and now shares with Peter Martins the title of Ballet Master in Chief. *Photo: Fred Fehl.*

112. 1976. Rehearsing the hornpipe from the third section of UNION JACK. This ballet was created as the New York City Ballet's contribution to the National Bicentennial Celebration of American Independence. The score by Hershy Kay was adapted from traditional British folk music, and the sets and costumes were by Rouben Ter-Arutunian. *Photo: Martha Swope.*

113. 1976. Being applauded by his company after the first performance of UNION JACK, May 12, 1976. *Photo: Costas.*

114. 1977. With Karin von Aroldingen and Sean Lavery, rehearsing the first movement ("Tales from the Vienna Woods") of VIENNA WALTZES. This ballet was the apotheosis of the waltz, using music by Johann Strauss the Younger, Franz Lehár, and Richard Strauss. It is one of the most sumptuous ballets produced by Balanchine's company, and is especially noted for the magical scenic transitions supplied by Rouben Ter-Arutunian. *Photo: Martha Swope.*

115. 1977. Taking a curtain call after the premiere of VIENNA WALTZES. *Photo: Martha Swope.*

116. 1980. Rehearsing APOLLO. Balanchine was able to show precisely what he wished for in the expression of his dancers' motion until the very end of his life. It was sometimes forgotten that, in his youth, he was an efficient performer of the classical repertory. His own behavior in instruction and towards performance remained the criterion of his company's style. *Photo: Steven Caras.*

117. 1980. Rehearsing Stephanie Saland as Polyhymnia in APOLLO. This, the earliest of Balanchine's concentrated neo-classical works, is actually a traditional classical work reduced to its essentials as a *pas de quatre*, with four of the most taxing roles for solo dancers in the extant repertory. *Photo: Paul Kolnik.*

118. 1980. With Mikhail Baryshnikov, rehearsing PRODIGAL SON, score by Sergei Prokofiev, sets and costumes by Georges Rouault. The ballet, made for Diaghilev's Ballets Russes, was premiered May 21, 1929, and was not seen after its initial performances until its revival for the New York City Ballet in 1950. The title role remains one of the great challenges for the virtuoso male mime-acrobat. Edward Villella was among its great interpreters, and the role especially suited Baryshnikov during his brief membership in Balanchine's company. *Photo: Paul Kolnik.*

119. 1980. With Mikhail Baryshnikov, rehearsing ORPHEUS. *Photo: Costas.*

120–121. The final movement of VIENNA WALTZES, set to Richard Strauss's first suite of waltzes from his opera *Der Rosenkavalier*. The photograph is of a 1983 performance by the New York City Ballet. *Photo: Paul Kolnik.*

122. 1974. Portrait with a rose. Balanchine, in his middle age, cultivated roses at his country house in Weston, Connecticut. He often compared his ballets to gardens and his dancers to flowers, which metaphorically expressed his attitude about the beauty, perfection, and fragility of his art. *Photo: Martha Swope.*

123. 1979. With Robert Irving, his esteemed collaborator and long-time Director of the New York City Ballet Orchestra. Irving, an Englishman, former conductor for the Royal Ballet, joined the New York company in 1958. He continued the development of the orchestra into a versatile ensemble that could successfully and beautifully cope with the complex music required by Balanchine's repertory. *Photo: Martha Swope.*

124. 1981. With Karin von Aroldingen and Adam Lüders, rehearsing HUNGARIAN GYPSY AIRS, set to Tschaikovsky's orchestration of the Sophie Menter pieces, a work that was premiered during the 1981 Tschaikovsky Festival. *Photo: Steven Caras.*

125. 1982. With Madame Sophie Pourmel, the beloved costume mistress of the New York City Ballet for many years, just before her retirement. *Photo: Paul Kolnik.*

126. 1980. Rehearsing ROBERT SCHUMANN'S 'DAVIDSBÜNDLER-TÄNZE'. Balanchine is on stage in the décor, designed by Rouben Ter-Arutunian, inspired by the German Romantic painter Caspar David Friedrich. The ballet, to piano pieces, effectively encapsulates a metaphorical biography of the composer's tragedy, containing not entirely by accident something of the choreographer's attitude towards life and death. *Photo: Paul Kolnik.*

127. 1982. With Peter Martins. A Dane, trained at the Royal Danish Ballet School and a principal with its company, Martins joined the New York City Ballet in 1970. He became the leading *danseur noble* of the pure classic academic style for his generation, and developed into a talented choreographer. He has assumed leadership of the School of American Ballet and, with Jerome Robbins, of the New York City Ballet. *Photo: Steven Caras.*

128. 1982. With Karin von Aroldingen, rehearsing the duet from ORPHEUS. The duet, in which Orpheus resists Eurydice's attempts to force

him to take a forbidden glance at her, is one of the most moving in the choreographer's repertory. *Photo: Paul Kolnik.*

129. 1981. With dancers, rehearsing ADAGIO LAMENTOSO, the final movement of Tschaikovsky's *Sixth Symphony*, the *Pathétique*. This ballet was composed as the solemn conclusion of the Tschaikovsky Festival. The symphony contained prophetic anticipation of the composer's own imminent tragedy. Balanchine's staging employed symbolism from the Russian Orthodox Liturgy and the presence of angelic witnesses to a martyrdom. *Photo: Carolyn George.*

130–131. ADAGIO LAMENTOSO. The tall wings of the angel guardians recalled the angelic presence of heavenly protectors in the icons of churches familiar to Balanchine from his earliest childhood. *Photo: Paul Kolnik.*

Photographs

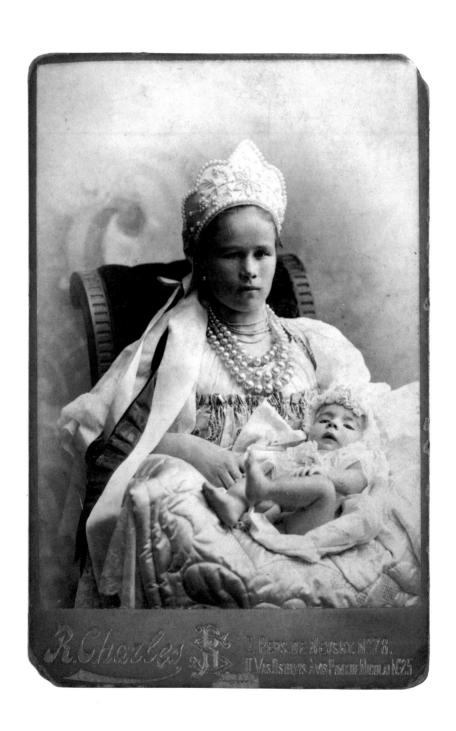

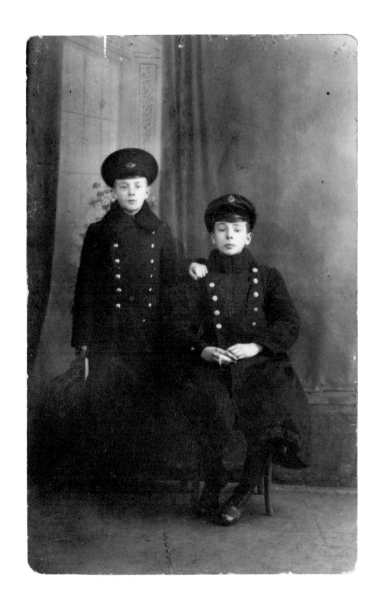

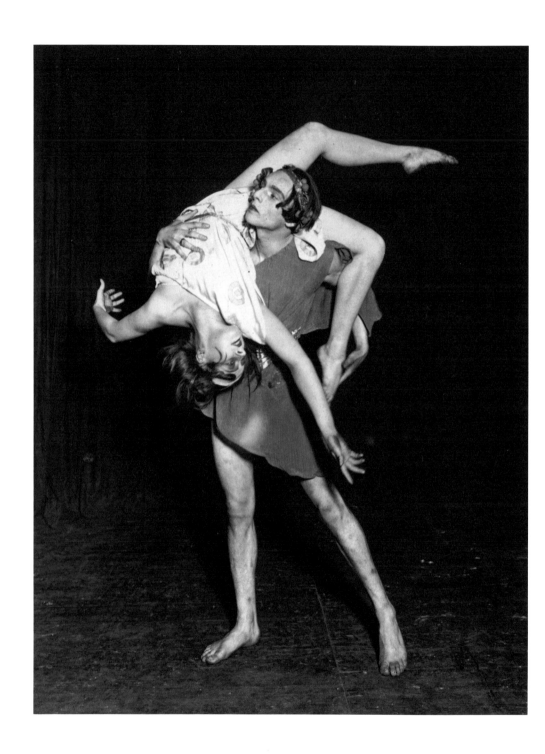

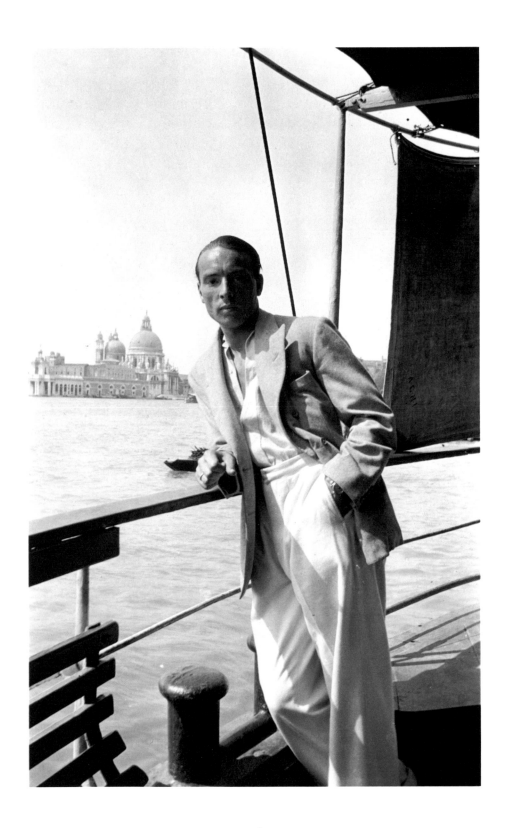

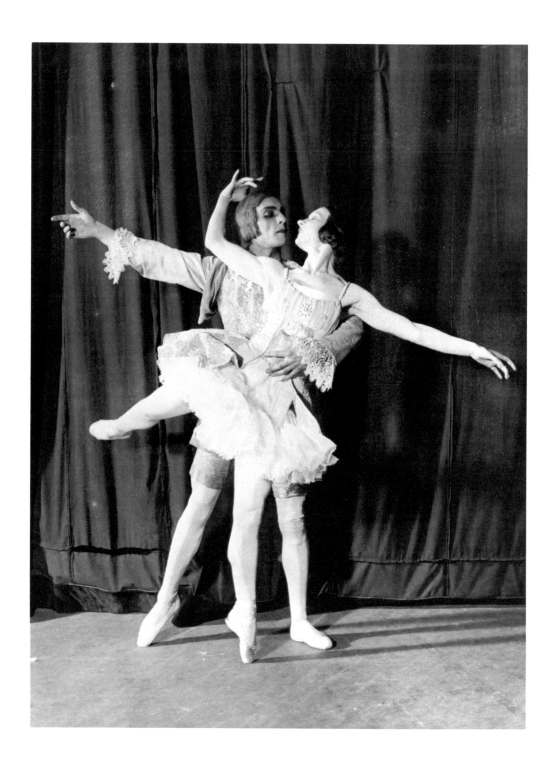

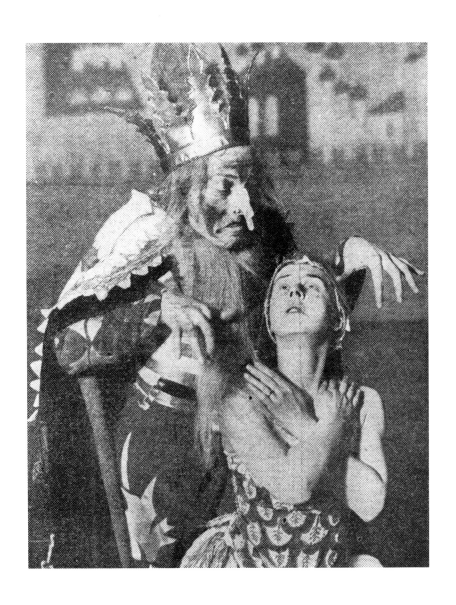

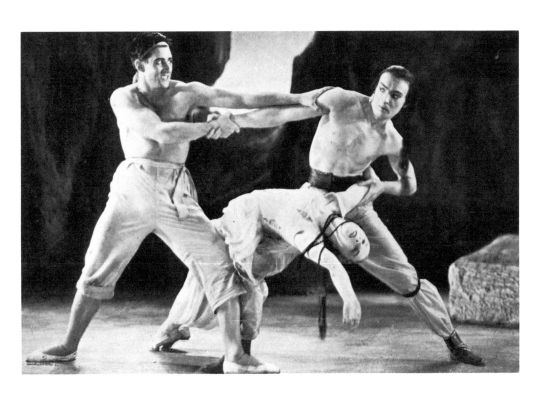

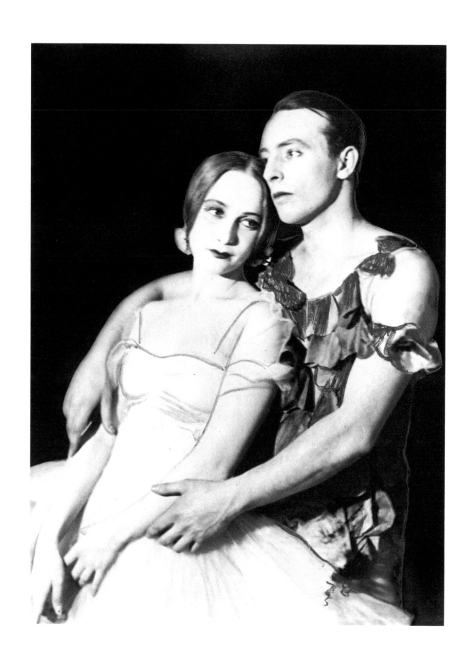

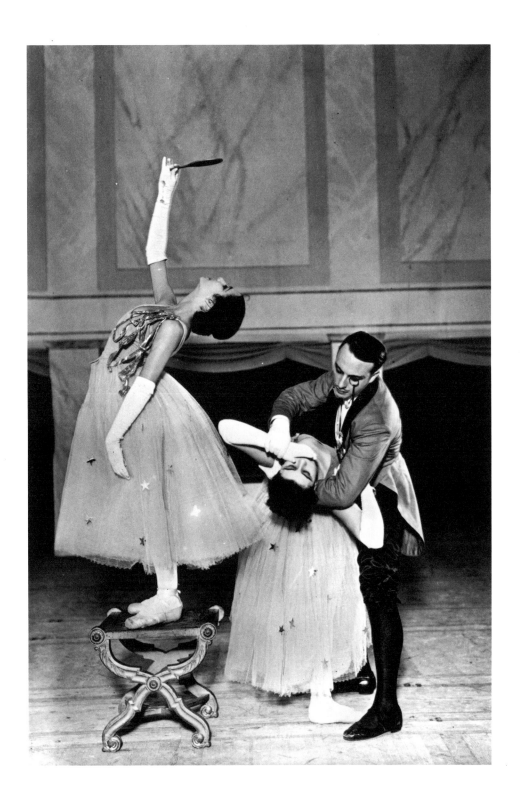

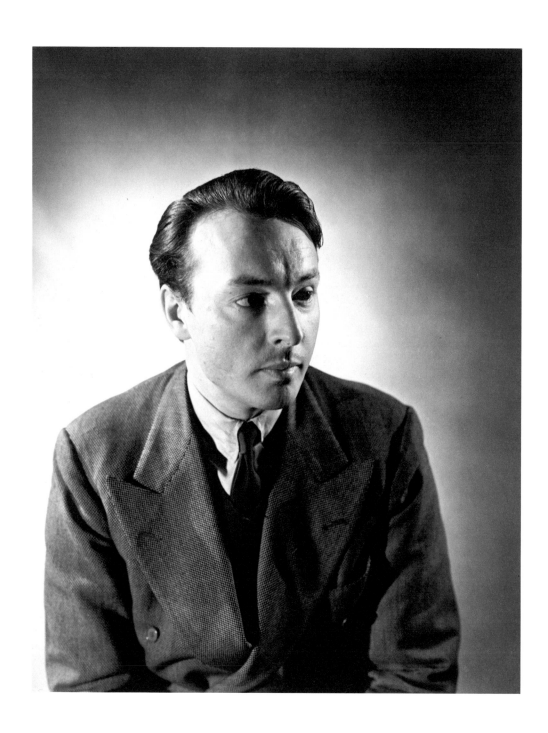

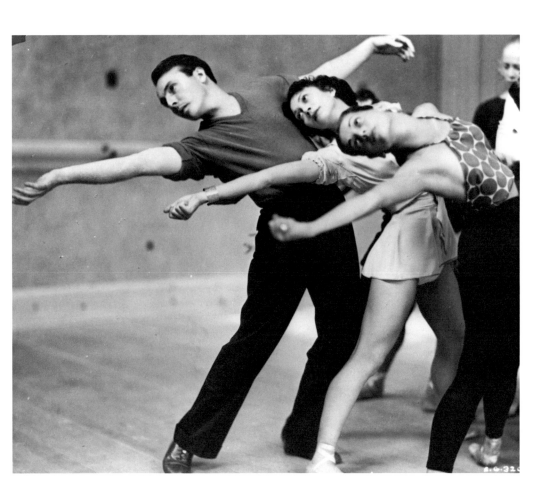

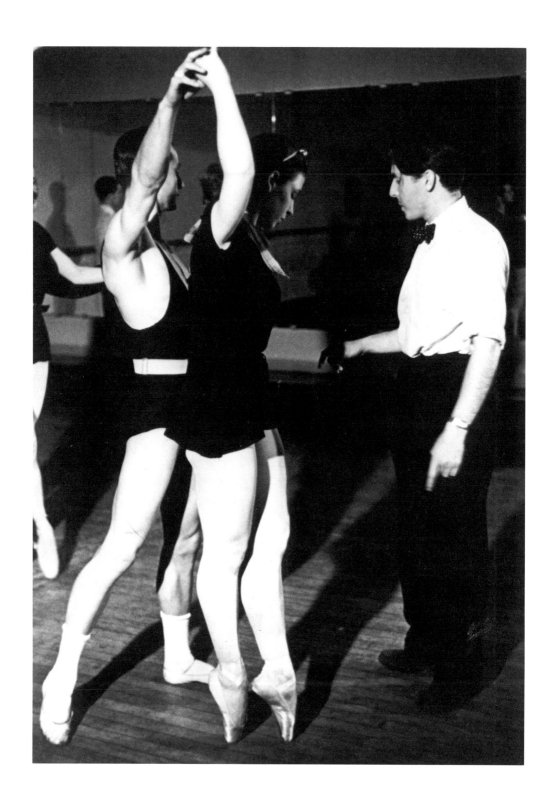

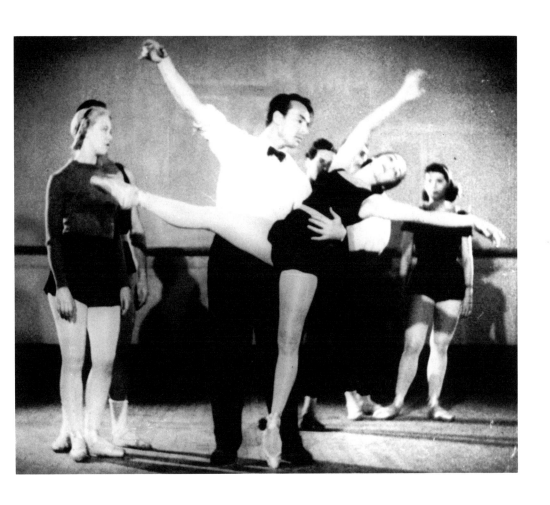

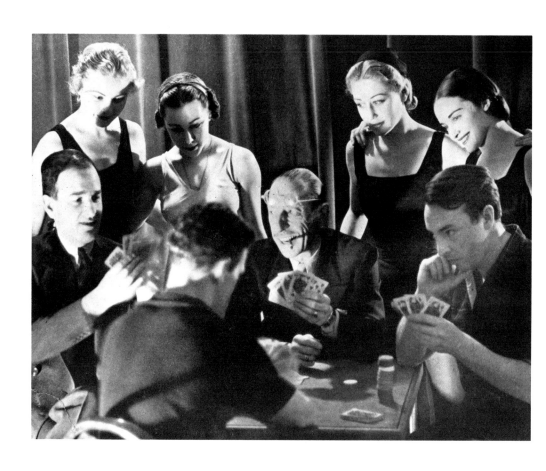

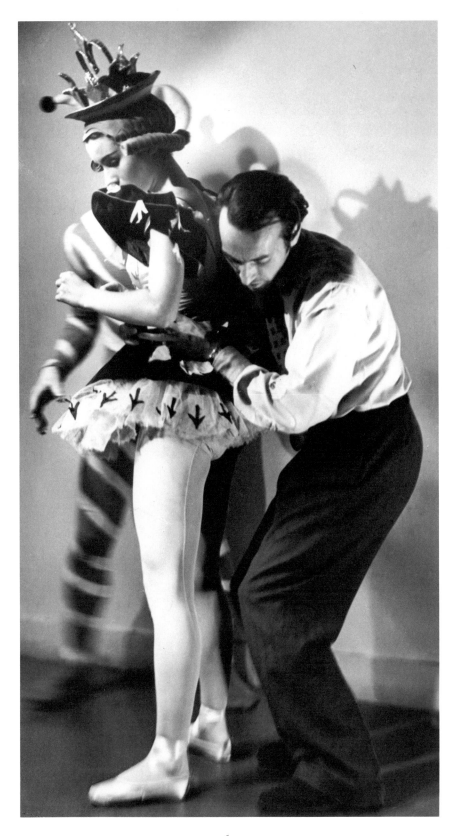

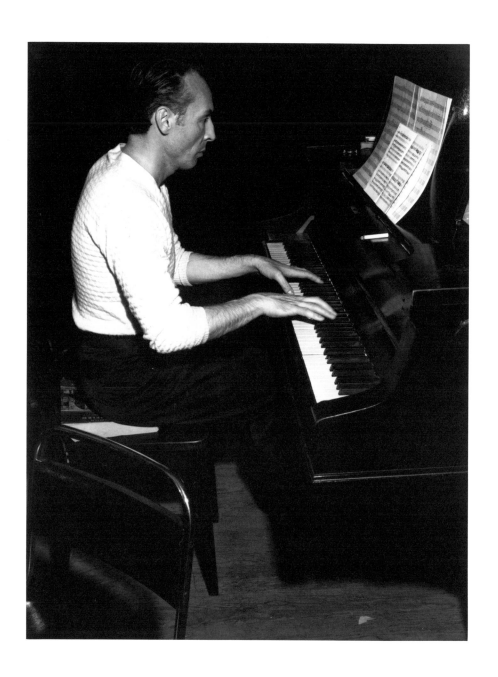

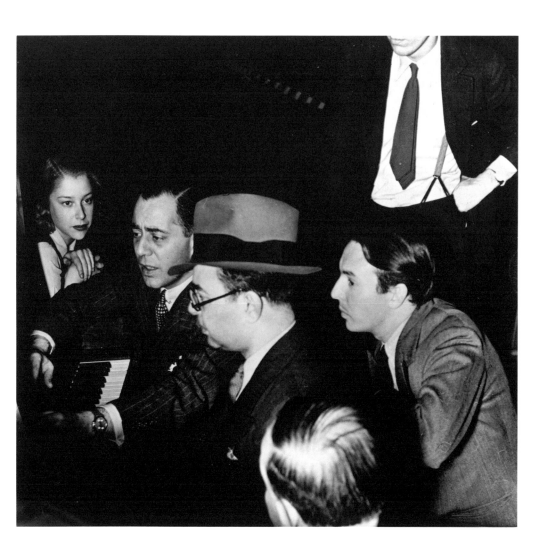

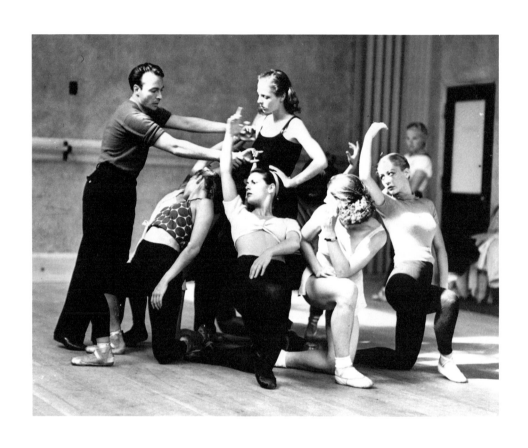

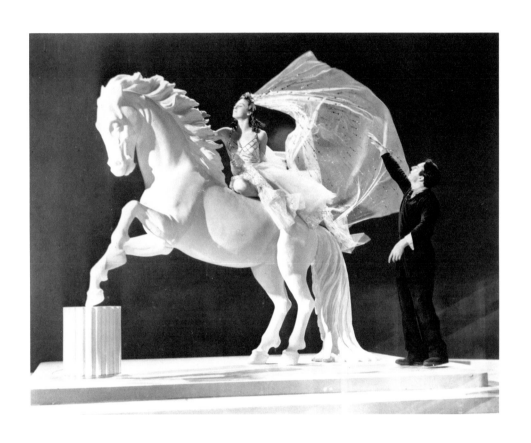

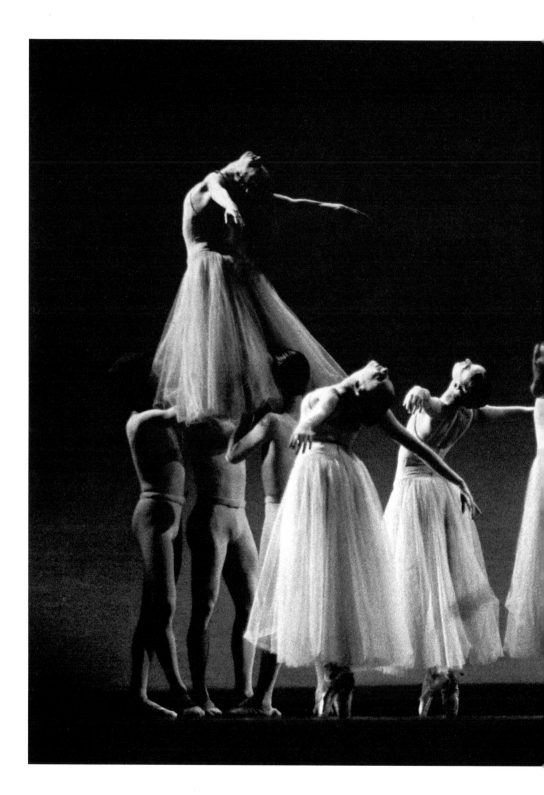

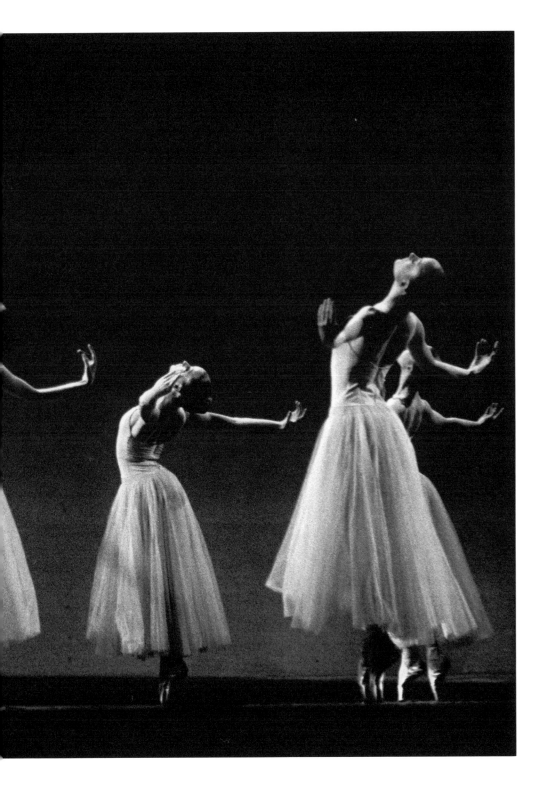

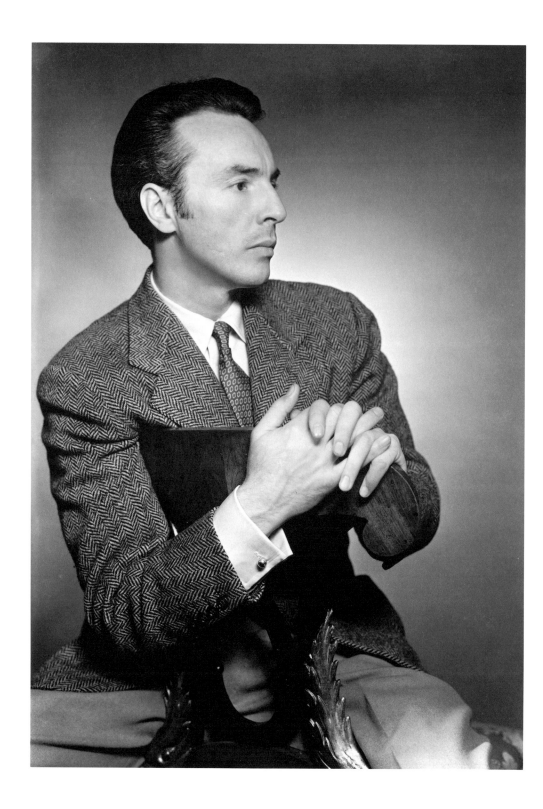

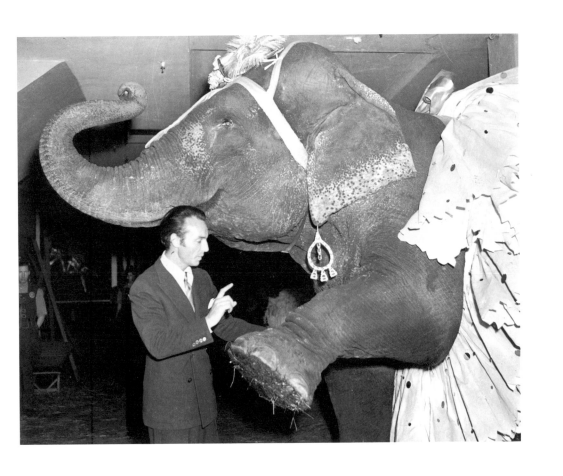

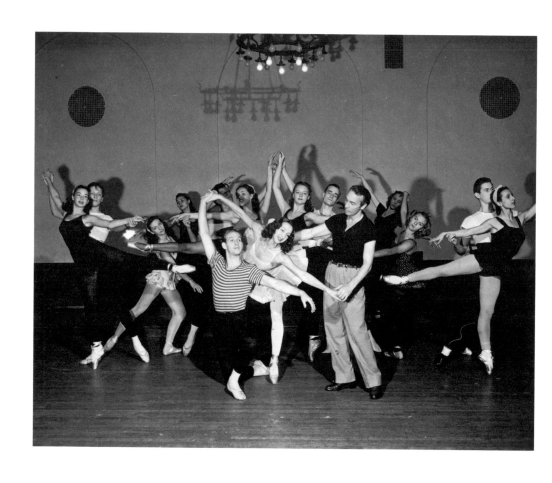

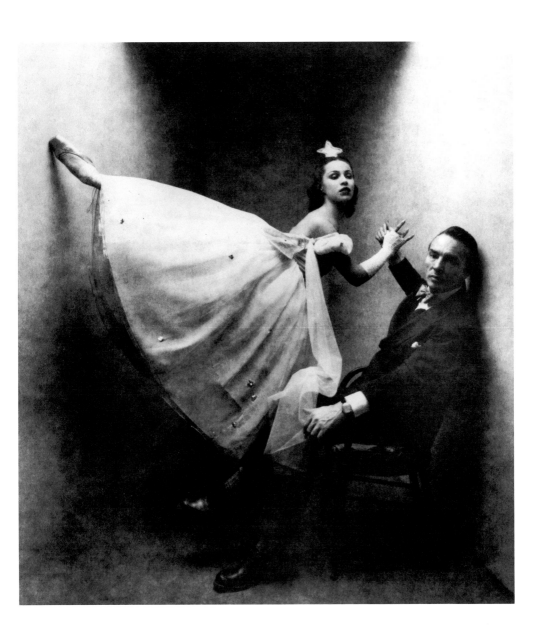

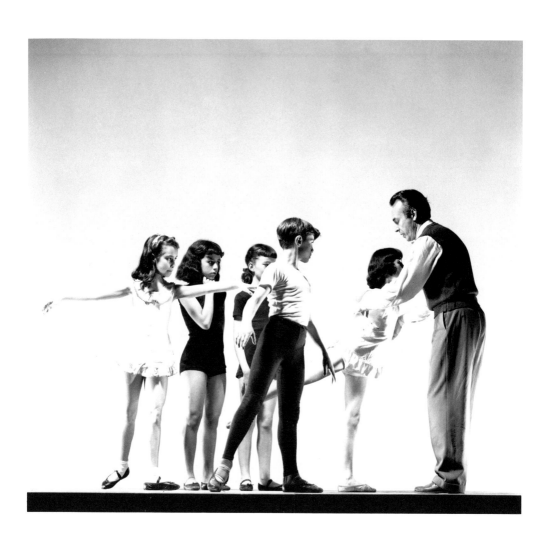

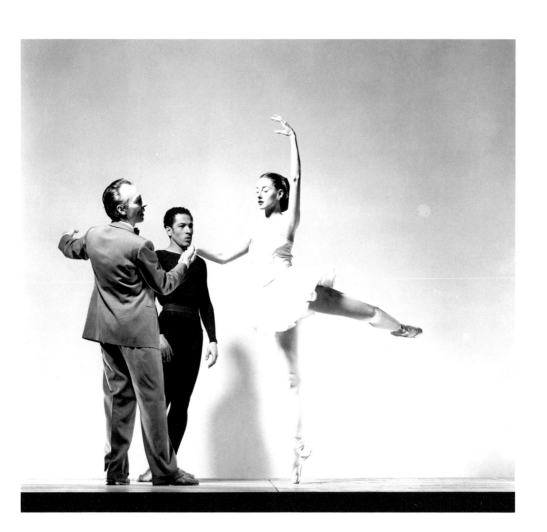

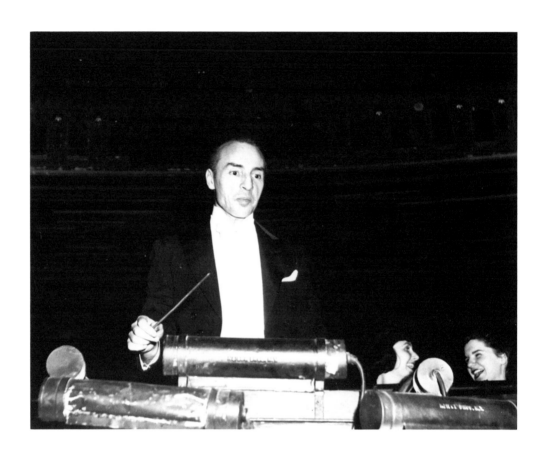

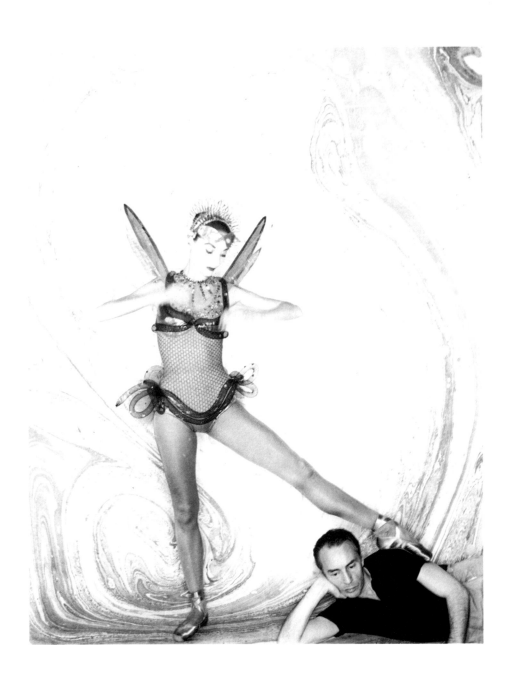

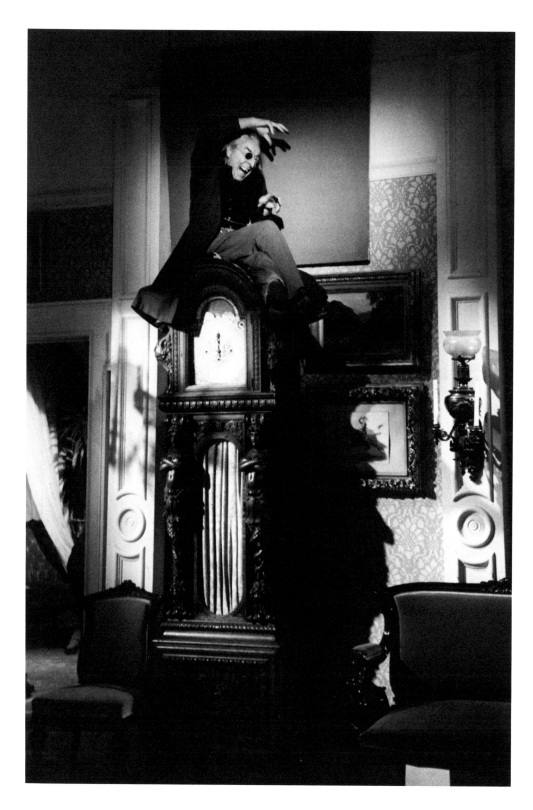

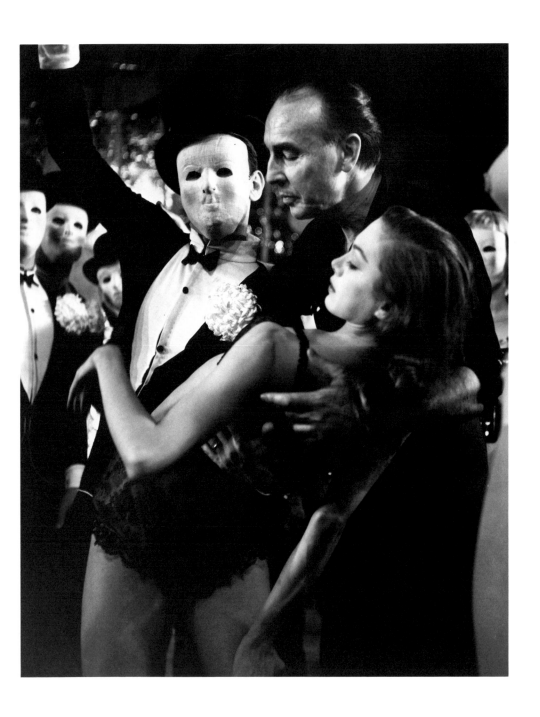

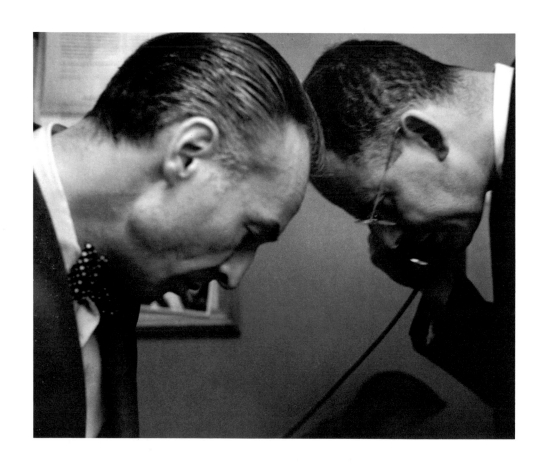

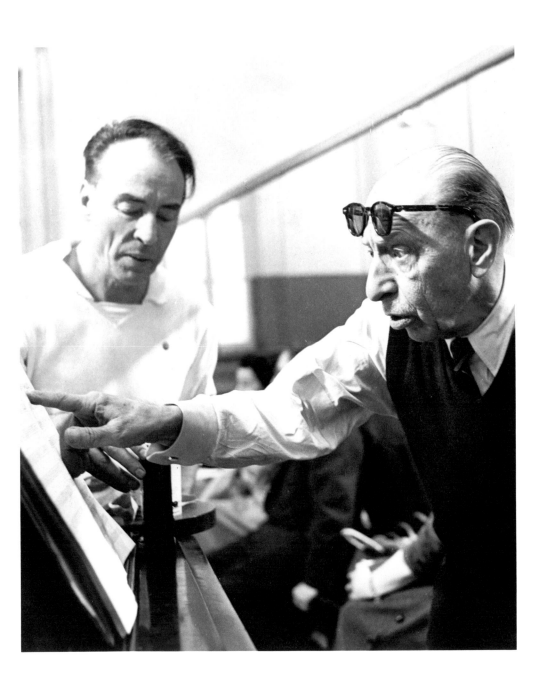

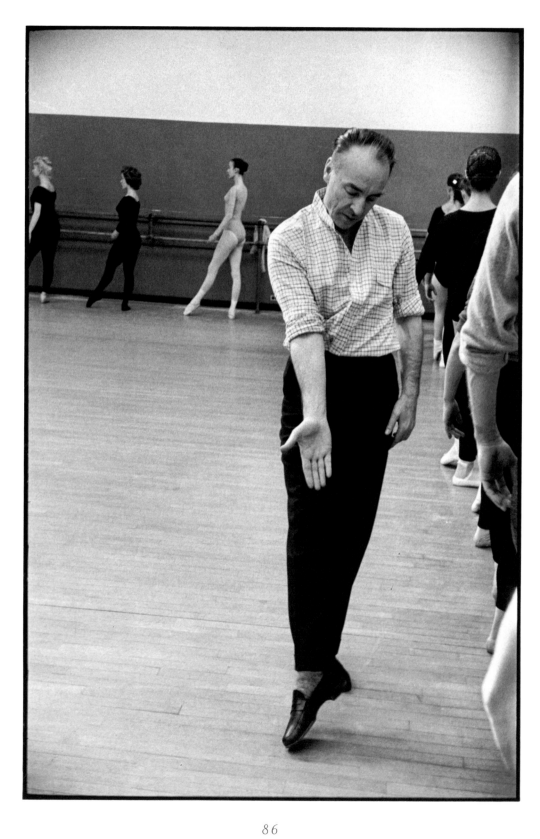

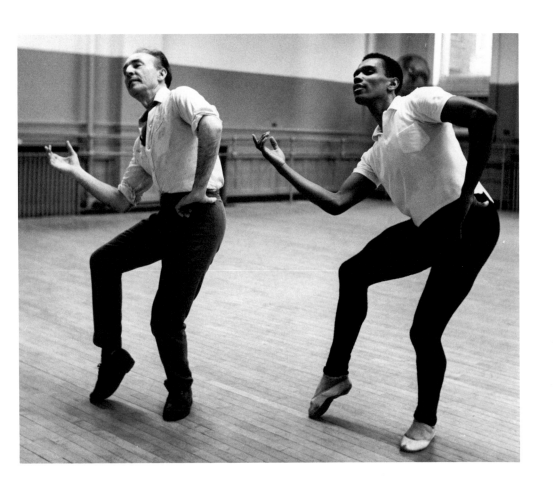

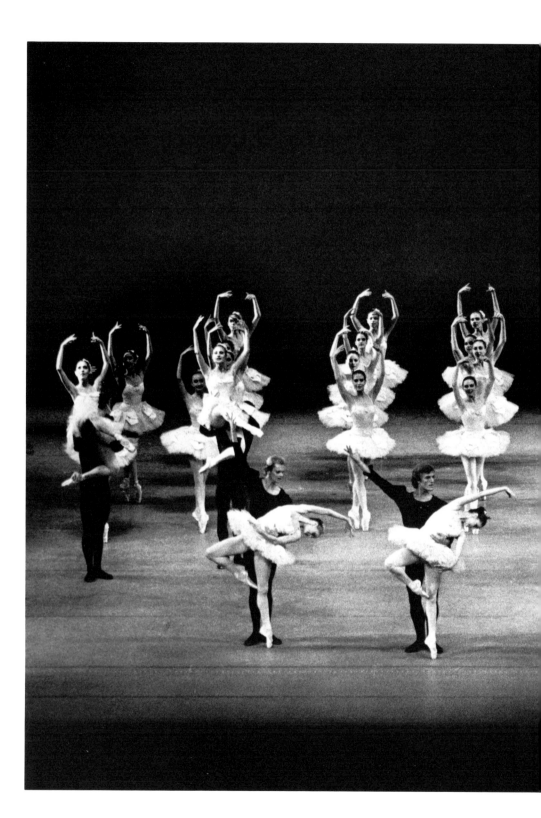

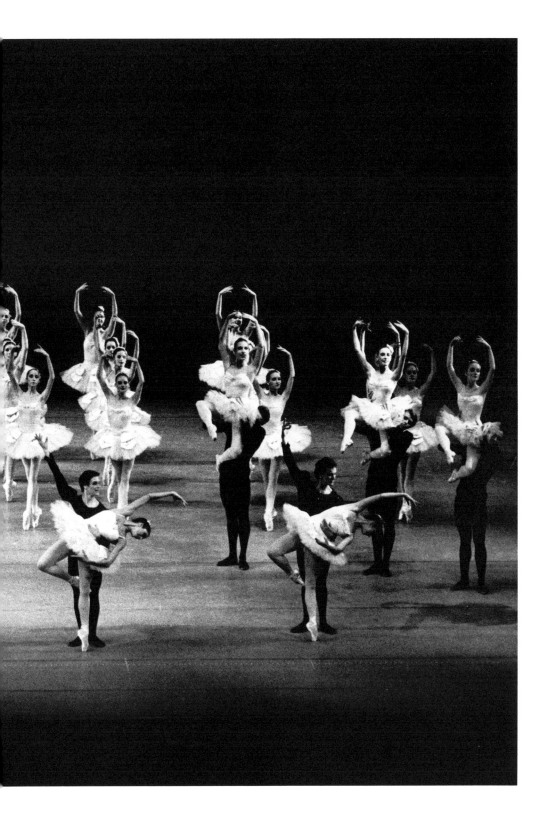

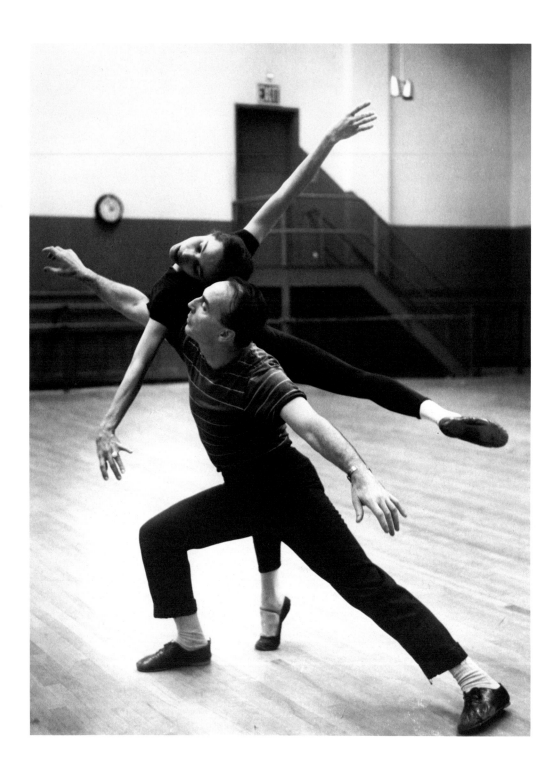

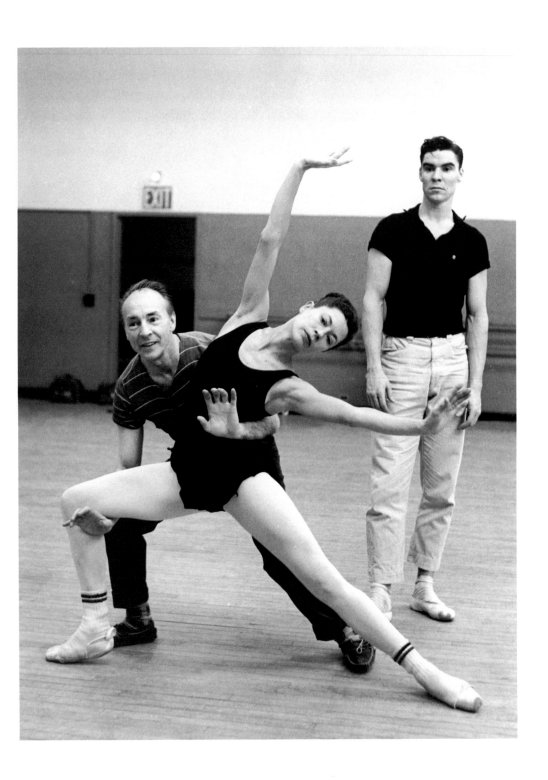

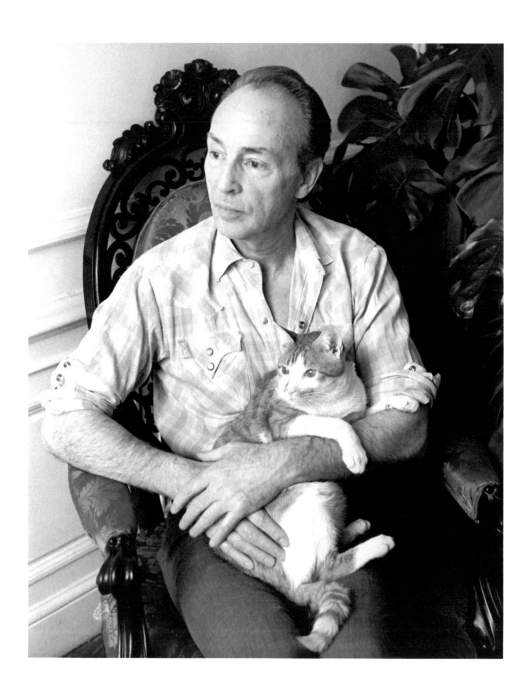

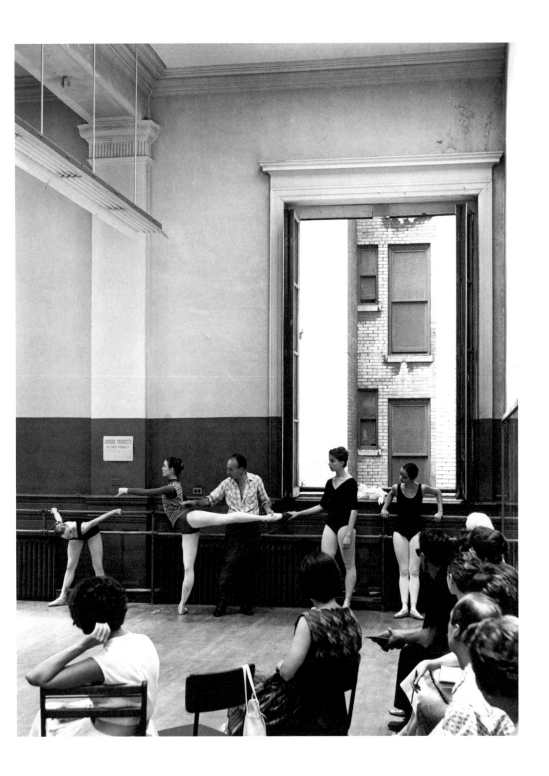

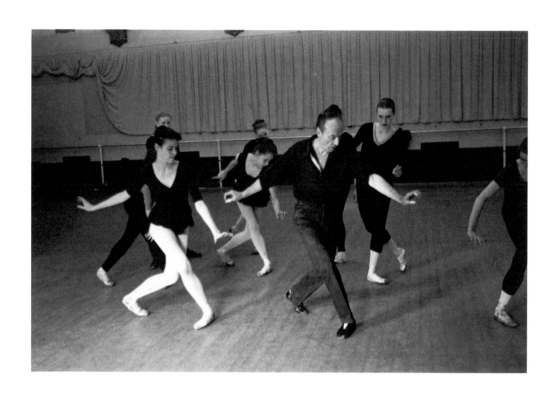

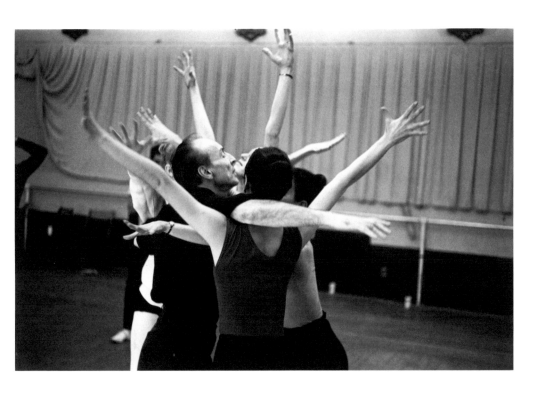

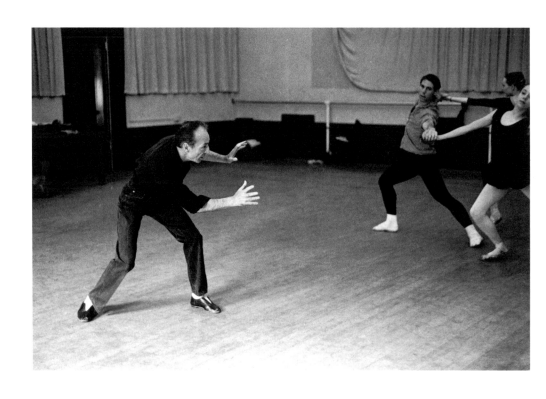

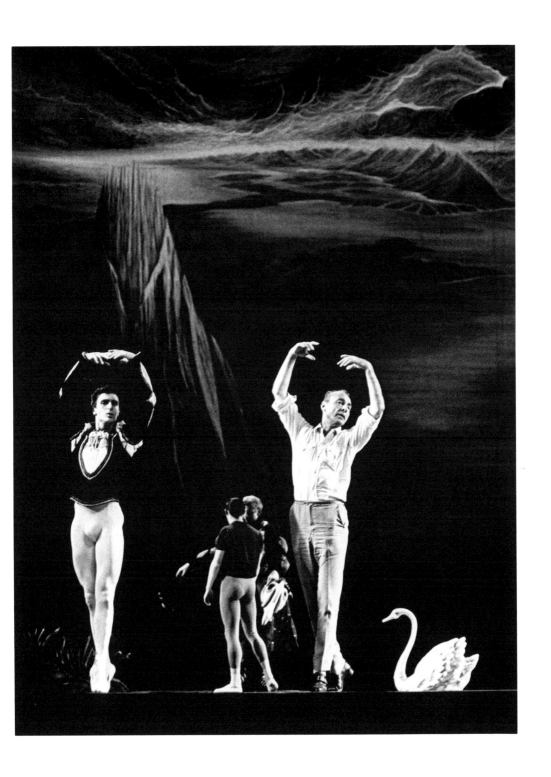

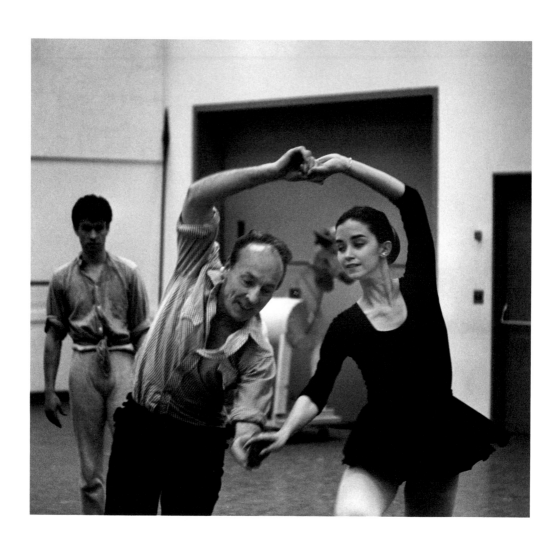

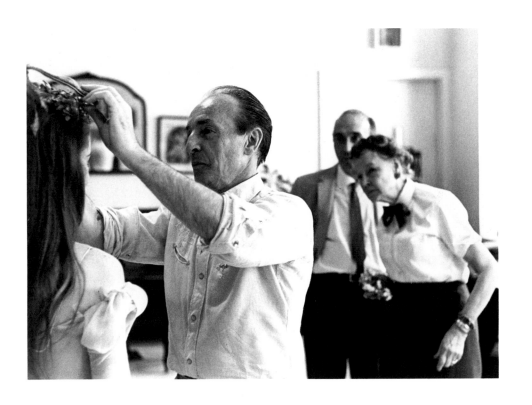

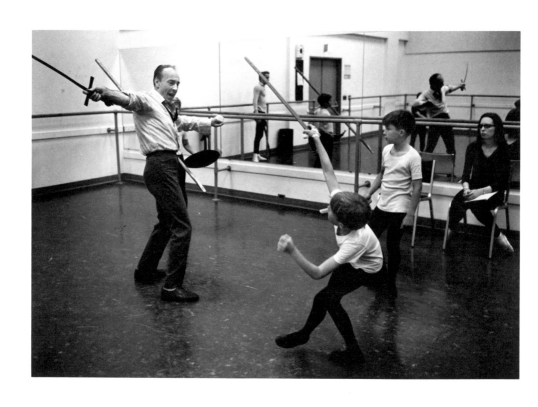

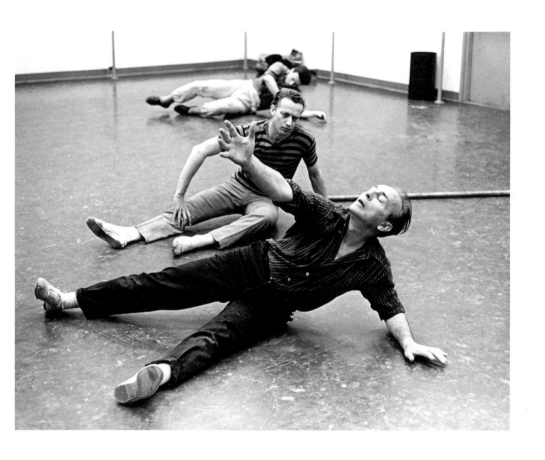

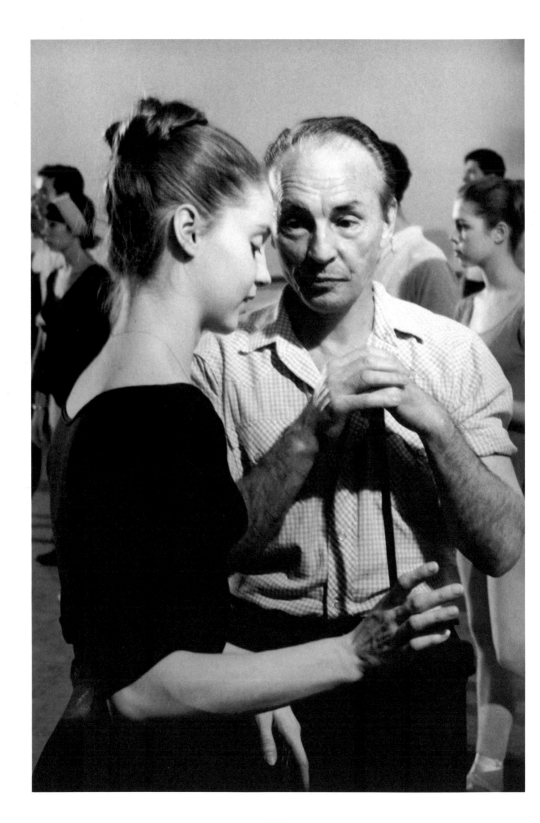

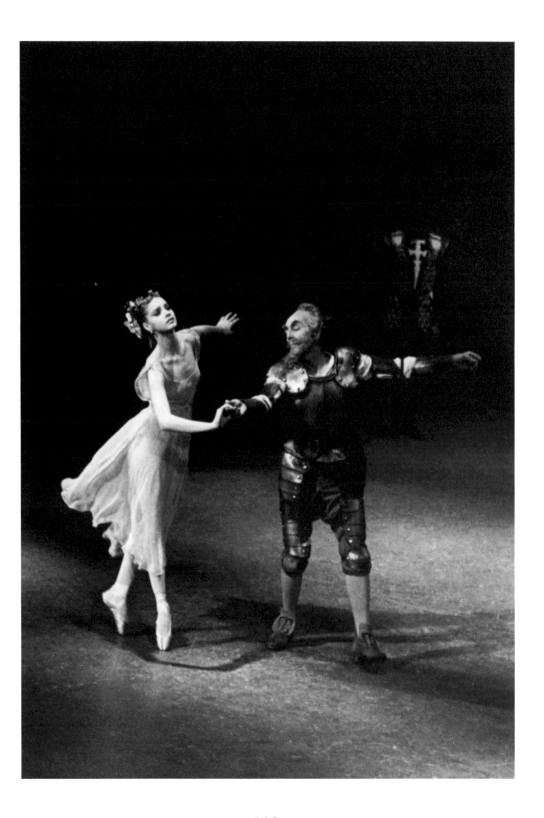

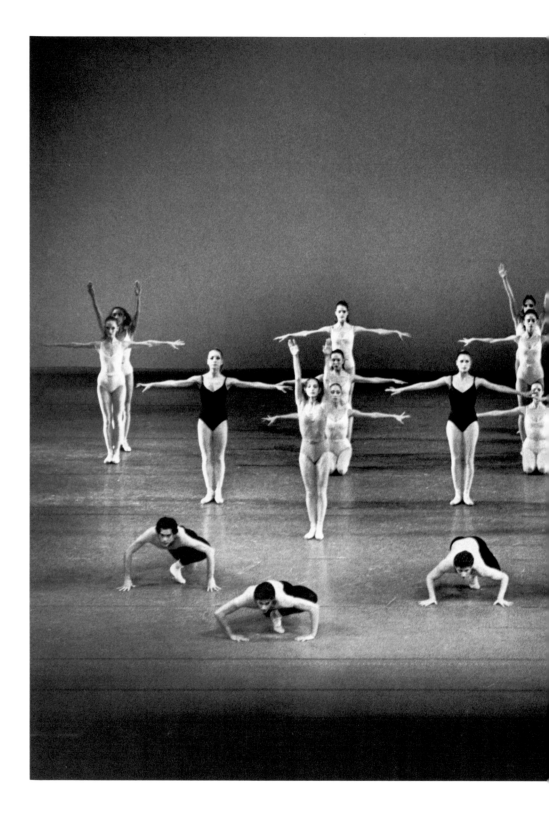

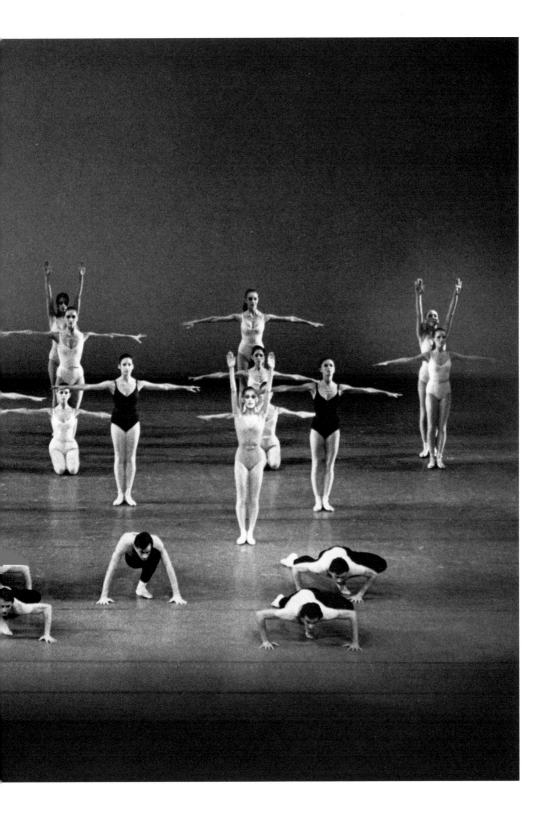

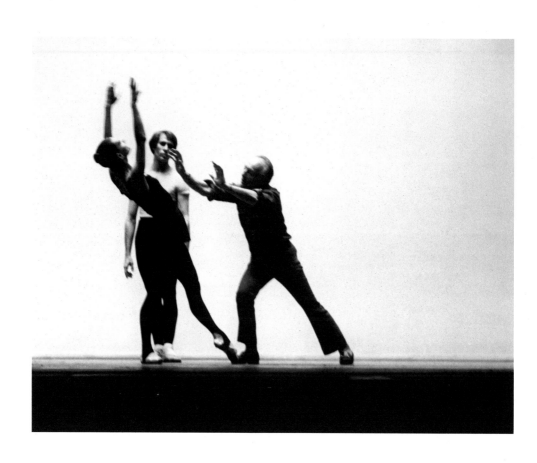

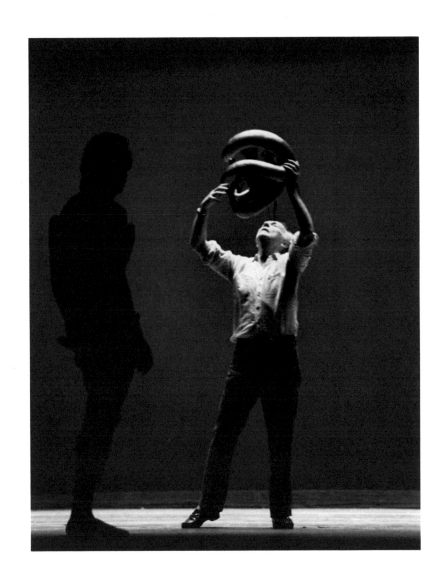

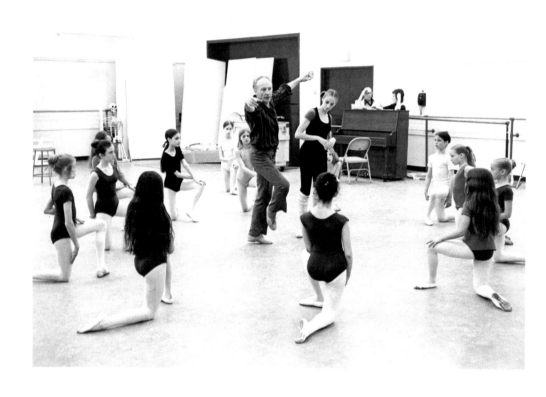

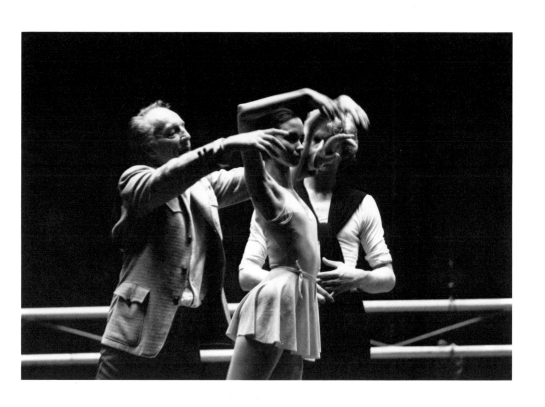

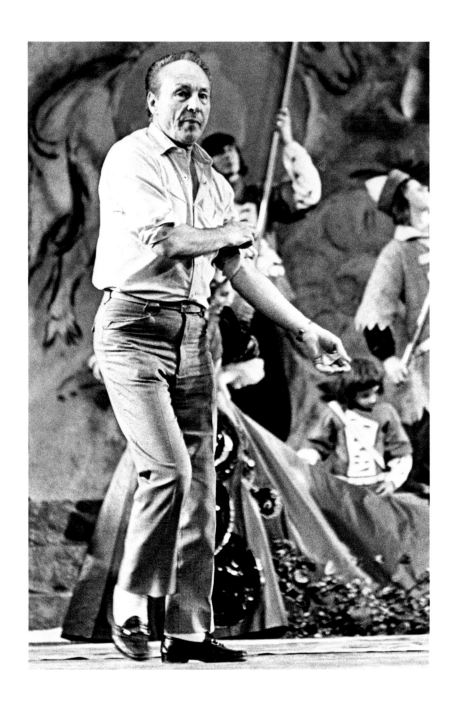

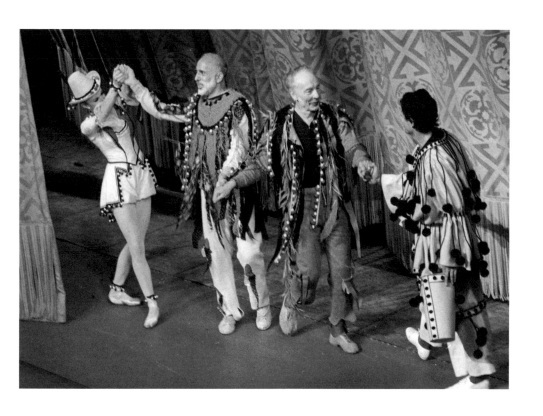

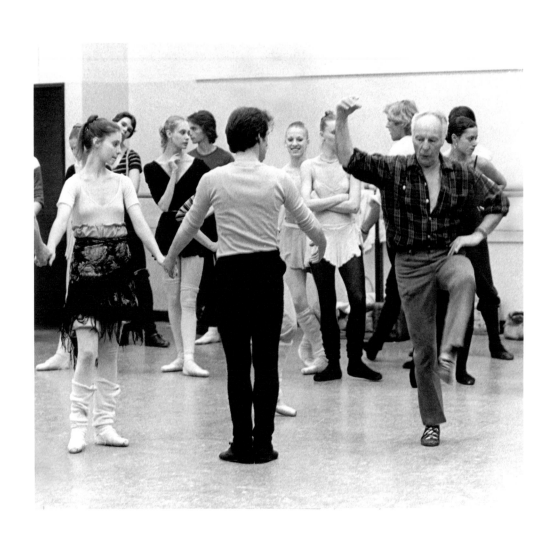

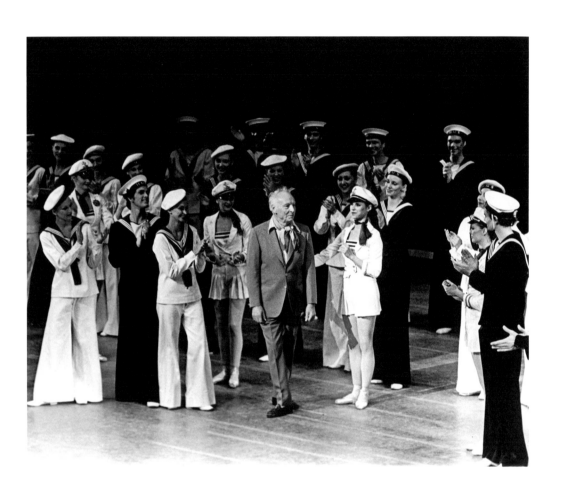

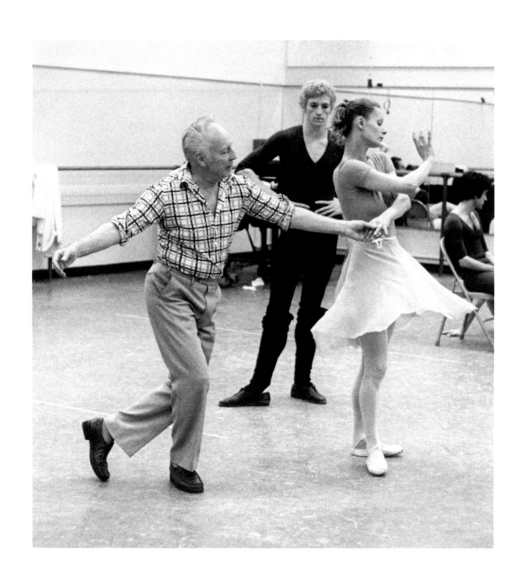

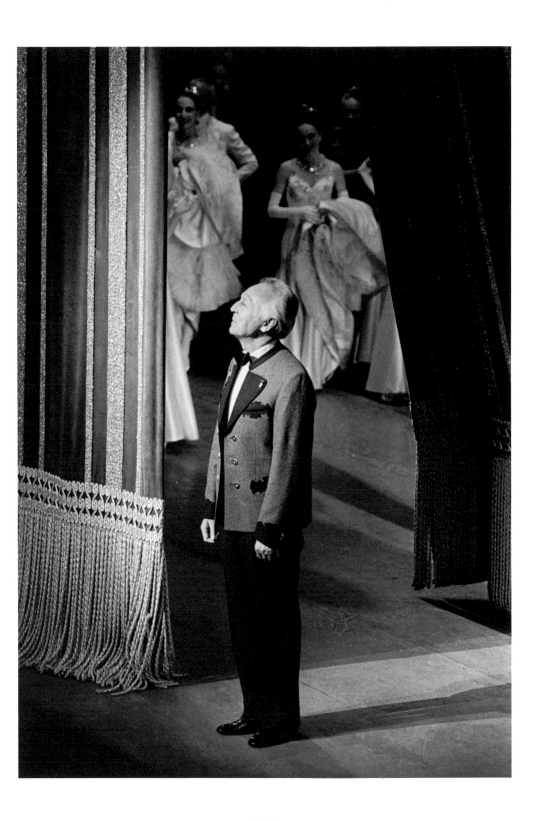

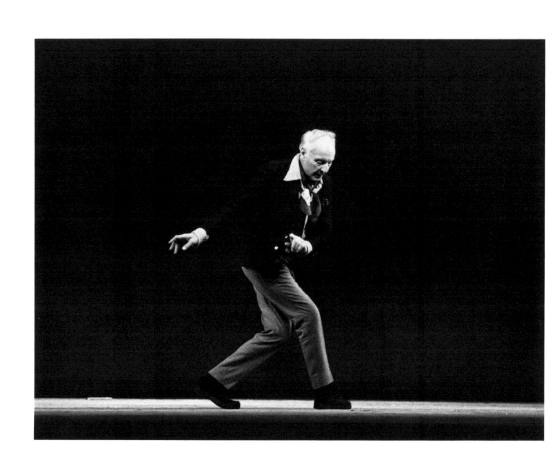

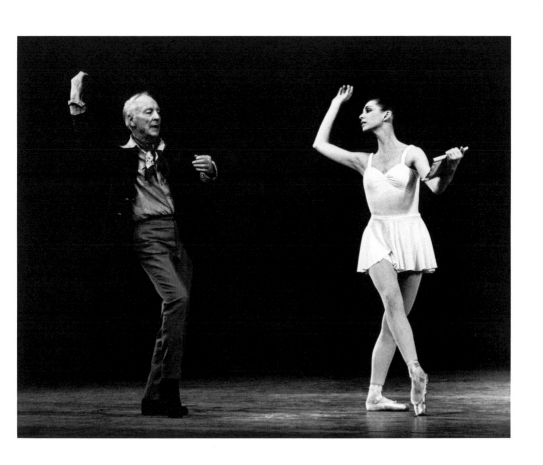

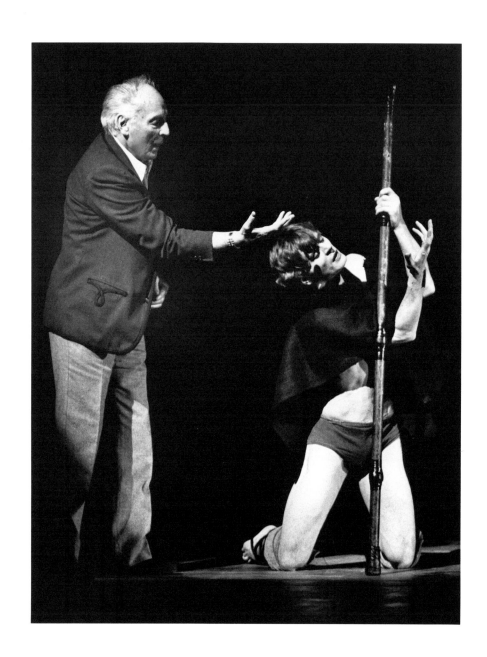

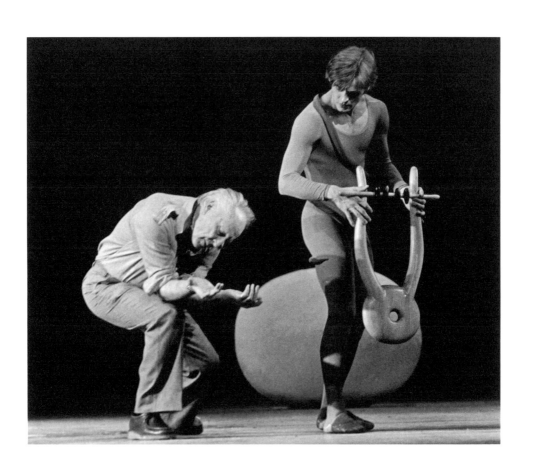

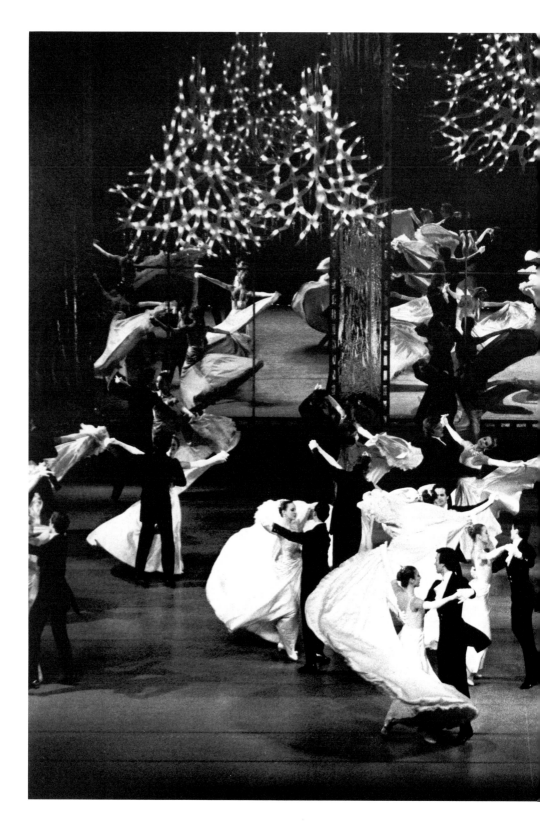

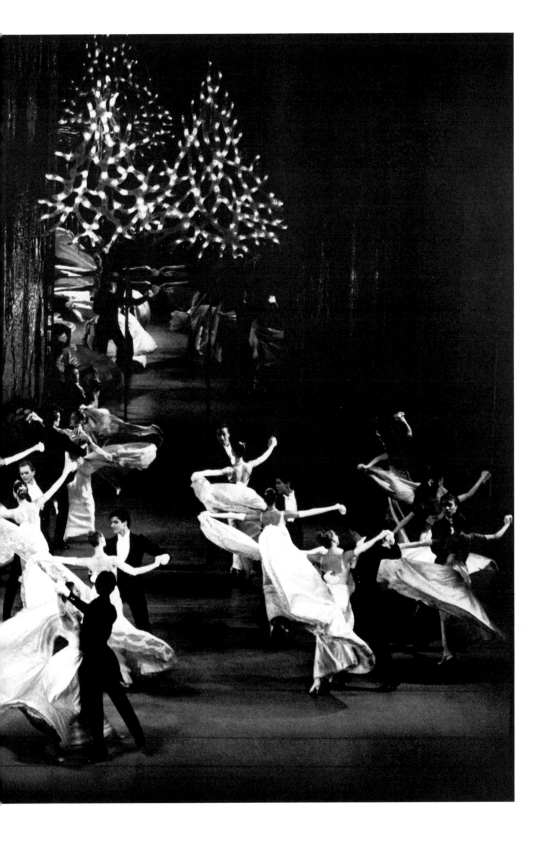

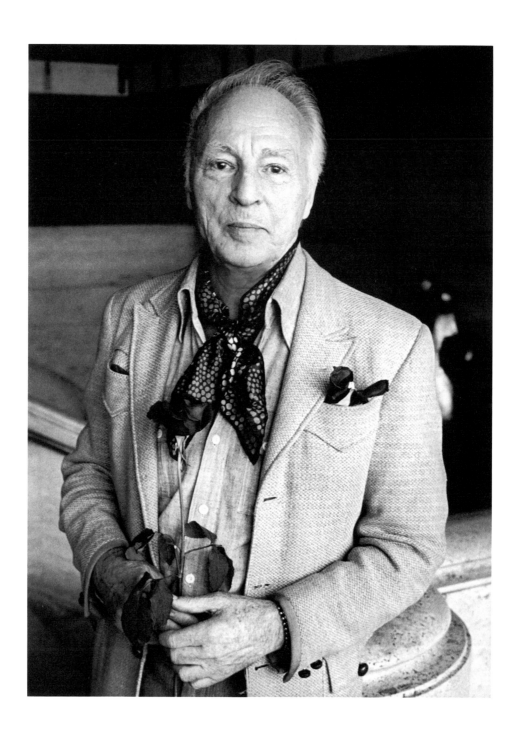

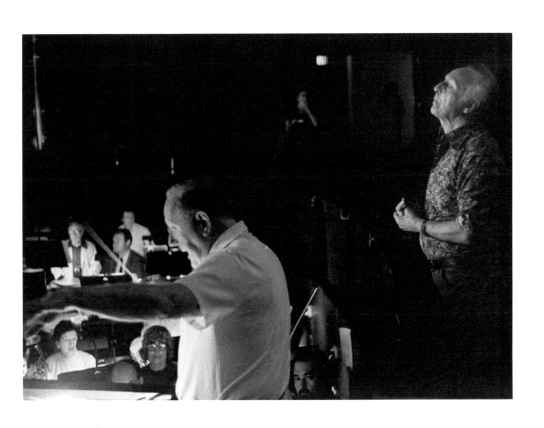

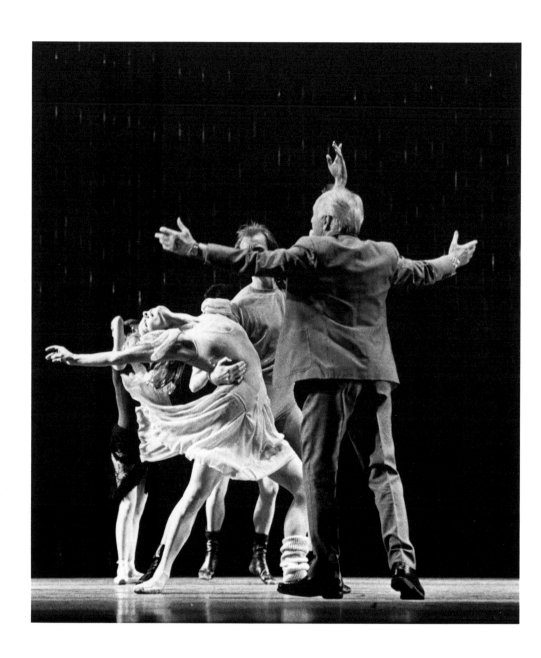

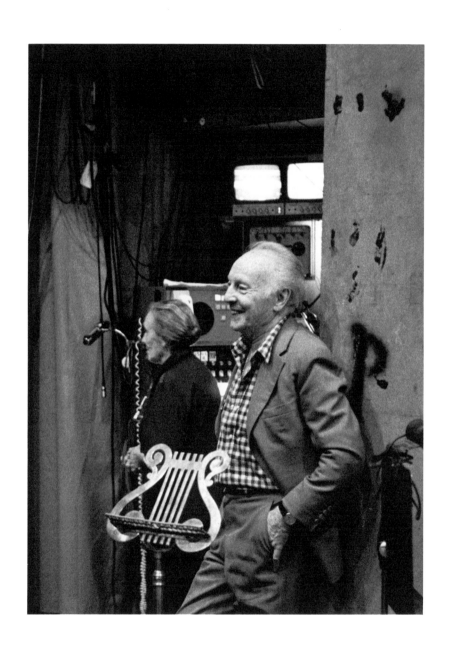

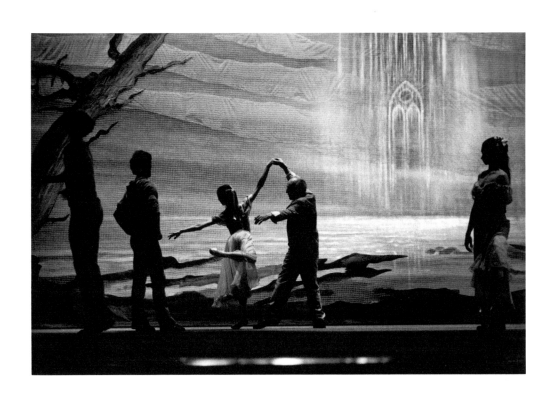

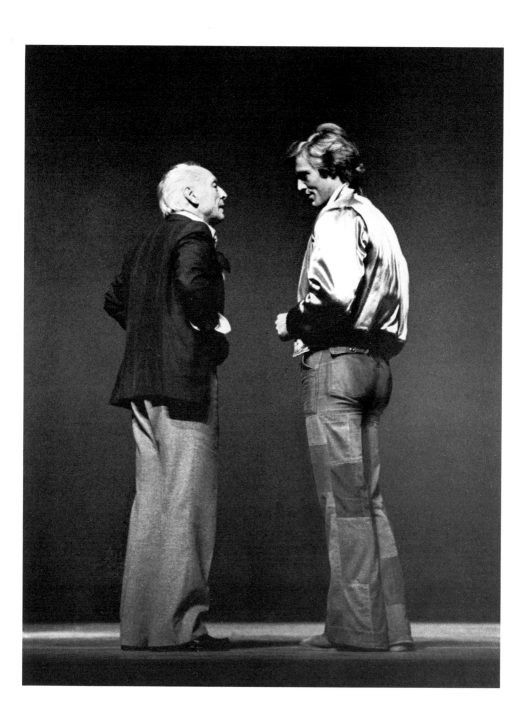

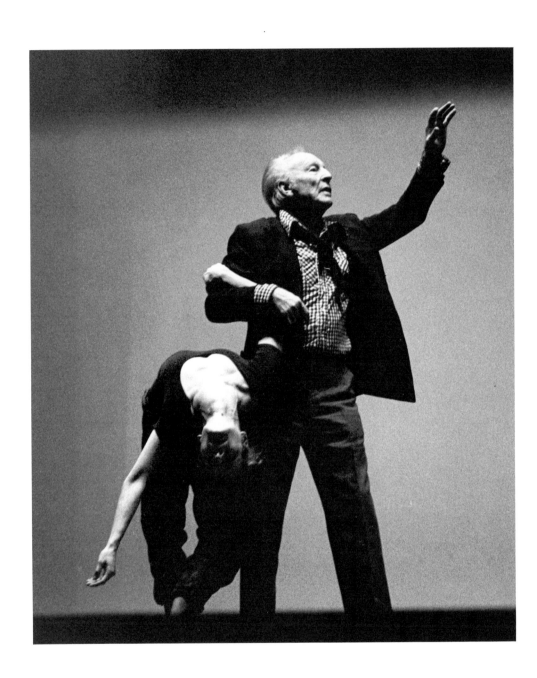

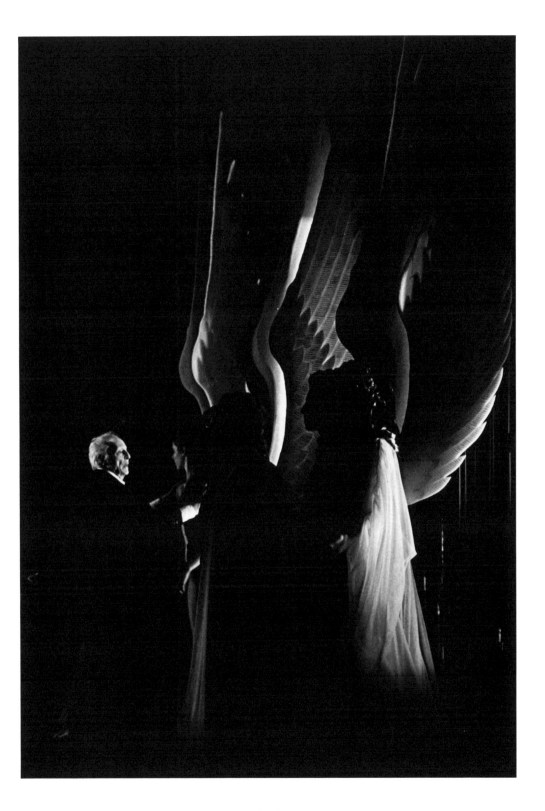

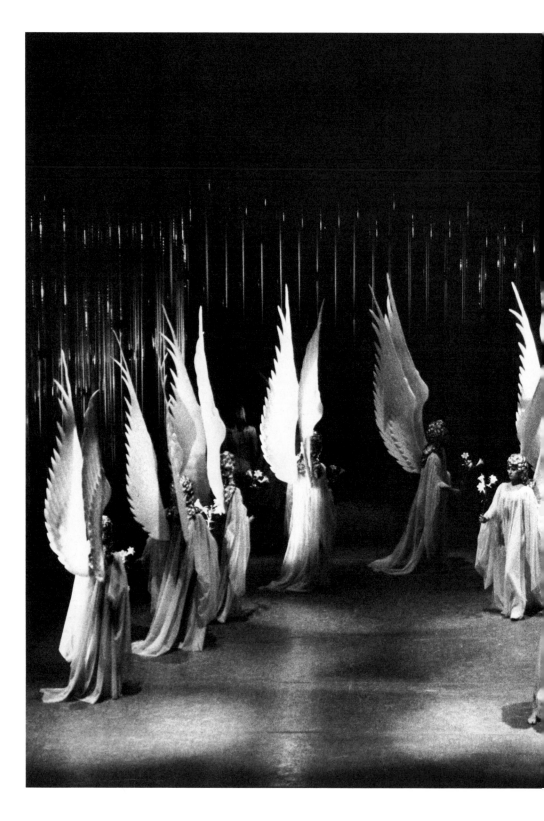

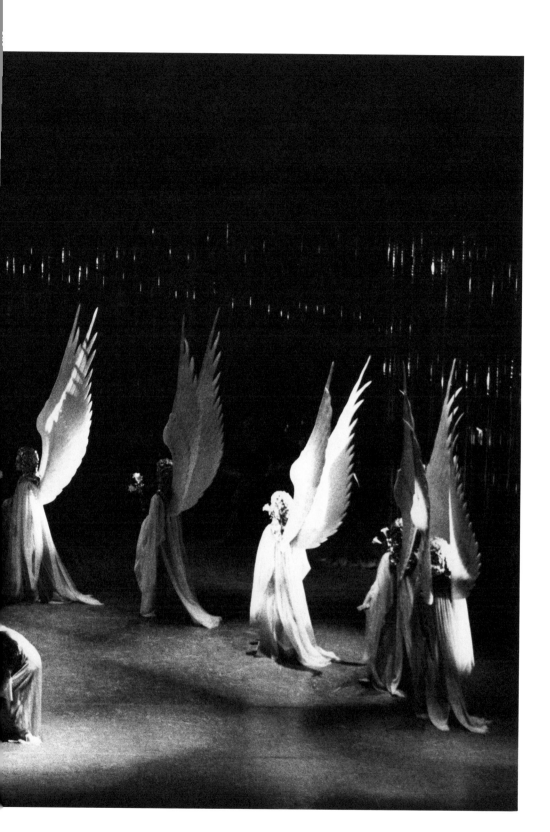

Two Talks with George Balanchine

JONATHAN COTT

I

Of all the art forms, music and dance seem to be the closest—like brother and sister, or like lovers. And whenever I think of your ballets, I hear the dancers and see the music.

Anything that doesn't belong to the world of words, you can't explain. People say, "What do you feel when you look at this?" We always have to compare with something else. "Is it beautiful?" "Yes." "Well, how beautiful?" "Like a rose, like a taste, like a wine." "And what does wine taste like?" "Like grass." It's always something else. So you describe my ballets in terms of hearing; and you're a writer, so you write. I myself don't have a writing style . . . not at all. Just a few words that I need to remember things.

The French poet Mallarmé once talked about a dancer "writing with her body."

Naturally. But not with words. You see, I got a message. Each one of us is here to serve on this earth. And probably I was sent here to see and to hear—that's all I can do. I can't see something that doesn't exist. I don't create or invent anything, I assemble. God already made every-thing—colors, flowers, language—and somehow there had to be a Mother. Our business is to choose. The more you choose, the more amazing everything is. But I can't explain what I do.

How do you explain a piece by Webern? You can say, mechanically, that it's twelve-tone music, but that doesn't mean anything to anybody. It's like saying something is a four-part fugue, but after a while, people listening to it lose hold of it. So the beginning of my ballet *Episodes* to Webern's music *Symphony* [Opus 21] is canonic. I had to try to paint or design time with bodies in order to create a resemblance between the dance and what was going on in sound.

The nineteenth-century theorist [Eduard] Hanslick said: "Music is form moving in sounds." This would also seem to be your definition of dance.

Absolutely. You have to have a sound in order to dance. I need music that's possible to move to. You have to hear the music—the timbre and the use of the sound. Music is like an aquarium with the dancers inside it. It's all around you, like fish moving through water.

Some choreographers take an important piece and then give the ballet an inappropriate title—a Brahms piano concerto, say, and then call it a "Rainbow" ballet by Brahms. He didn't write a rainbow. I, personally, can't do dances to a Brahms symphony or to Beethoven—perhaps little moments from a specific piece. But you can't take one of their symphonies and dance to it.

You've choreographed much Stravinsky, but never Le Sacre du Printemps.

It's impossible, terrible. Nobody can do it. And Stravinsky's *Les Noces* is impossible, too, and it shouldn't be done. The words are tough Russian words, and when at the end of the piece the Bridegroom, very drunk, screams out that he and his Bride will live together forever and that everyone will be jealous of their good life . . . well, he's unhappy when he sings that, because the marriage will be a disaster. He's never seen her and she's never seen him. It's a tragedy, really, when you hear this sung in Russian—those words and that almost funeral music.

Speaking of Stravinsky, someone once described him at a Nadia Boulanger class in Paris, sitting at a piano and "inventing a chord"—playing a chord, then taking one note out and putting another in until he had something very special. Don't you do the same thing?

Absolutely. There's gesture and timing, and I leave things alone or take something out, put something else in instead. I can't take a formula and do just anything with it. Naturally, in a few seconds I can create very banal movements with a formula, but to do something important, to occupy time and space with bodies—several bodies that stop in time and pass—you have to look at them and say: "Not right now, don't do that, get out, do it this way." You have to put things together like a gefilte fish. That's how I do it.

In the second pas de deux of your ballet Stravinsky Violin Concerto, *I get*

the sense of inert matter being formed—the artist shaping his materials. The dancers' last gestures, especially, suggest this. Did you have this idea in mind?

To me, it's the music that wants you to do certain things. Dance has to look like the music. If you use music simply as an accompaniment, then you don't hear it. I occupy myself with how not to interfere with the music. And at the end of this pas de deux I made a gesture as if to say, "How do you do, Stravinsky?" That music is very Russian—reminiscent of old, nostalgic Russian folk songs—and I knew what Stravinsky meant, I understood and felt it.

It's very difficult to make a gesture such that it looks like a sound. It's also like your asking and making a question—two people addressing the world. So, at the conclusion, I made a little bow to Stravinsky. And I also did that in the duet to the *Symphony in Three Movements*—there's a little Balinese-type gesture (Stravinsky loved Balinese culture), like a prayer, and that, too, was for the composer.

Stravinsky's body is gone, but he's still here. What could he leave, his nose? He left me a cigarette case and other things. But the music is really what he left, and when his music plays, he's right here.

There are at least two basic spiritual ideas concerning the nature of dance. The first of these is conveyed in a statement by St. Augustine: "All the dancer's gestures are signs of things, and the dance is called rational, because it aptly signifies and displays something over and above the pleasure of the senses." The second is revealed in a statement by the Sufi poet Rumi: "Whosoever knoweth the power of the dance, dwelleth in God."

To me, these are two ways of saying the same thing. Now, the dervishes don't perform specifically for the sake of money or beauty, but, personally, I have to do ballets that will attract a public. If people don't come, we don't have a company, dancers and musicians can't get paid. Once they have a salary, they can eat—and then we can tell them: "Don't eat, get thin, do this, put on some makeup, you look like hell!" *Train* them. And then you can do certain dances that aren't meant specifically to entertain the public.

In the great ballroom finale of Vienna Waltzes, *you've created a ballet that entertains but that also suggests a world of waltzing dervishes!*

I agree.

And in the midst of these whirling dancers is the heroine who, just as she seems about to awake—both sexually and spiritually—swoons and faints like the archetypal Victorian maiden.

Or like some of the characters in Turgenev . . . yes, there it is! Hegel once said that people want to see their lives onstage. That means, for example, that one man might think: "I'm married, my wife and children have left me, and I'm unhappy and feel that I'm going to kill myself. And that's what I think Art is—people should play for me my story." Another guy has a bad stomach. So everyone has a different story. Look at *Jesus Christ Superstar*: People say it's very good, they think they get something from it, but they get *nothing* from it, it's miserable. That's no way to find God—going to sleep, having a drink.

I've always wanted to know whether or not you like rock 'n' roll.

It's not my cup of tea, I'm too old. Jazz is my time—and some Gershwin and Rodgers and Hart. But I'm not really American yet. I can't understand rock 'n' roll words: "Auh-uh-er-er-you-er . . ." The boy and girl meet and then never meet again . . . and then . . . what . . . "you went away" . . . er . . . "you and I holding hands . . ." I don't understand it.

Getting back to dance and how you choreograph: When you first hear the opening intervals of a piece of music— Webern's Symphony*—do you immediately visualize these intervals, or feel them in your body?*

No, I feel something can be done, but if I don't try it out, then I can never do it. You can't sit down and think about dancing, you have to get up and dance. You take people and move them and see if their movements correspond to the music. And I have to know the music. In Webern's *Symphony* I made the dancers turn upside down at one point in order to parallel the use of the musical inversion. And near the ending of Stravinsky's *Movements for Piano and Orchestra* I have dancers marking the composer's returning twelve-note row . . . but now slowed down, spread and stretched out. These certain things I do, naturally, but as little as possible. I don't imitate the notes of a piece.

When you listen to music, you can hear lots of notes in one ear, but you can't see collected movements, as if they were a pill that goes into your eye and dissolves immediately. Massine used to have people dancing everywhere—he called it contrapuntal ballet. "Contra," which means "against," actually—in reality—means "together." As I've said

many times, the movements of arms, head, and feet are contrapuntal to the vertical position of the body.

Writing about Webern's use of retrograde canons, the composer Ernst Krenek once pointed to something extremely fascinating. As Krenek stated it: "The accuracy and elegance with which the reversibility of these models is worked out emanate from a peculiar fascination, seeming to suggest a mysterious possibility for circumventing the one-way direction of time." Does this have any relationship to what you feel about Webern's music or about the way you choreograph a work like Symphony?

Even if it's so, you can't and shouldn't try to effect this. Several years ago I read an article about the reverse-time sense, and I think that the world must have this sense. In the usual time sense, everything decays— what is young gets older and separates—and the world, as we know it, is like that. But there's another world where all this decayed material, in our time sense, goes into . . . whatever it is and reverses. It's as if you're born dead, get younger, and die at birth. Not only that . . . it may be that *this* time sense is going on at the same time as the other one. Why not? It's everything at once. As you've reminded me before, I still believe what I once said: "I'm not interested in later on. I don't have any later on. We all live in the same time forever." . . . Of course, they talk about the Black Hole. But think: The Black Hole will probably disintegrate, too, because it's a part of our world. So the Black Hole feeds himself—it's a *he*, probably, the Black Hole—he eats up the light . . . and then when he's completely fed, he'll explode like mad!

Some of the endings of your Stravinsky ballets, in particular, feel so strongly to me like beginnings that I look forward to the endings.

Like beginnings. Yes. But remember, we have to be thinking of this on the level of particles. And you don't really become aware of it, you only think of it that way. I think that the reverse-time sense is true because I've always thought that it couldn't be that everything goes in just one direction. We know Andromeda goes one way and continues to go that way until it becomes dust. But what else? What about on the level of subatomic particles? I feel something, but as Bottom the Weaver says in *A Midsummer Night's Dream,* "My eye cannot hear and my ear cannot see."

In my ballets, of course, there's an order. A dance must start and go somewhere. I can't start until I know why I have to do something.

"Why this?" I say. "Why this way?" If I don't know why, I can't start a ballet. Physically, I do. But before that, I must know, I must be sure why *this* is *that* way. It's inside of me—I have to feel inside of me that this little bundle is right and that it represents something clear, with a beginning, middle, and end.

The painter Paul Klee once wrote about the idea of male sperm impregnating the egg as a way of describing the formal energy of art: "Works as form-determining sperm: the primitive male component."

I don't believe in this at all. It sounds like the painter Pavel Tchelitchew, who once described this idea in reverse. I've often said that the ballet that I represent makes the woman most important. If the woman didn't exist, there wouldn't be a ballet. It would be a man's ballet company, like Béjart's. That's a good example. There are, of course, women in his company, but it's the men—the way they look—who are most important. His *Le Sacre*, by the way, is the best anyone has done. It has a certain impact, I think, and I was amazed how almost right—physically and musically—his version was. But in my ballet, the man is a consort and the woman is the queen. Terpsichore is our muse, and little Apollo's head is covered with curls. Ballet is a feminine form, it's matriarchal. And we have to serve her.

It's strange, though—when I see your pas de deux—especially those in Agon, Stravinsky Violin Concerto, Duo Concertant, Pithoprakta, *I pay less attention, finally, to the fact that there's a man and a woman dancing, but rather start thinking of things like identity, personality, separation, reflections, duplications.*

That's right. Some people, though, see in these pas de deux only pure man-woman relationships: "The woman didn't have any guts, the man wasn't sexy enough." This isn't my business. And what you're saying is absolutely right. Strange things happen. In the Webern [*Episodes*] pas de deux, for example, it's like a roof . . . raindrops on a crystal roof.

In a pas de deux like that I get a sense of two, or many, parts of myself, and I feel the dance as a kind of energy or electric field, lighting up my emotions.

That's what it is. It exists.

These pas de deux always seem to be distillations and compressions of the whole

ballet, incorporating everything that occurs before and after it and raising it to an extraordinary level. "Ripeness is all," Shakespeare said. Moments of ripeness. Which reminds me of the beautiful pas de deux in the second act of A Midsummer Night's Dream.

When Bottom the Weaver is transformed into an ass, he says: "The eye of man hath not heard, the ear of man hath not seen, man's hand is not able to taste, his tongue to conceive, nor his heart to report what my dream was." It sounds silly, but it's full of double and triple meanings. And I think that at moments like this, Shakespeare was a Sufi. It reminds me of St. Paul's First Epistle to the Corinthians [1 Corinthians 2, 9]: "Eye hath not seen, nor ear heard, neither have entered into the heart of man, the things which God hath prepared for them that love him." What Bottom says sounds as if the parts of the body were quarreling with each other. But it's really as if he were somewhere in the Real World. He loses his man's head and brain and experiences a revelation.

And then what happens? Bottom wants to recite his dream, which "hath no bottom," to the Duke after his and his friends' play-within-a-play is over, but the Duke chases them away. And the really deep and important message was in that dream.

At one point, when I was choreographing the ballet, I said to myself: In the last act, I'll make a little entertainment and then a big vision of Mary standing on the sun, wrapped in the moon, with a crown of twelve stars on her head and a red dragon with seven heads and ten horns . . . the Revelation of St. John!

Why didn't you do it?

Well, because then I thought that nobody would understand it, that people would think I was an idiot.

"The lunatic, the lover and the poet/Are of imagination all compact," Shakespeare says elsewhere in the play.

That's it. I knew it was impossible. I wished I could have done it. But instead, in the second act, I made a pretty—not silly or comic—pas de deux to a movement from an early Mendelssohn string symphony [*Symphony No. 9 in C*]—something people could enjoy.

But that pas de deux is so mysterious and calm . . . perhaps you did, in fact, give us Bottom's dream.

It doesn't matter what it is. What's important is that it's pretty and makes you happy to see it. What it is—a flower or a girl or a dance or music—you can do what you want with it, you can talk about it, take it home with you, think about it, and say it represents this or that . . . that's fine.

So the inexplicability of dance is similar to Bottom's vision.

Absolutely.

You seem to choreograph these pas de deux with a feeling of adoration and of devotion, and the result is a kind of rapturous grace.

Naturally, I do it that way . . . but I don't tell anybody. When I was a child, I heard about a kind of enormous water lily—it was called Victoria Regina—that opens only once every hundred years. It's like wax, and everything is in there, everything lives . . . by itself, and it doesn't tell anybody anything. It goes to sleep and then comes back again. It doesn't say: "Look at me, now I'm going to wake up, I'm going to jump. . . . Look, Ma, I'm dancing!" But if you happen to be around, and are ready, you'll probably see something.

It's like the time capsule with everything in it. Or like the seed that, when you plant it, becomes an enormous tree with leaves and fruit. Everything was in that little seed, and so everything can open. The tree of dance is like that. It just takes a long, long time to blossom.

[Summer, 1978]

II

Someone once suggested that painting is not a profession but actually an extension of the art of living. Do you think that might be said about dancing?

It's probably true. You see, all I am is a dancer. It started long ago, you know. At first, I didn't want to dance, but I was put in the Imperial Ballet School in Russia. I got accustomed to it and began to like it. Then I was put onstage; everyone was well-dressed in blue on a beautiful stage, and I liked participating. And it became a kind of drug. I don't know myself except as a dancer. Even now, though I'm old, I still can move, or at least I can tell exactly how it feels to move, so that I can teach and stage ballets.

You can ask a horse why he's a horse, but he just lives a horse's life. It's like the story of the horse that goes to a bar: The barman serves him, and when he leaves, the people say, "But that was a horse!" And the barman just replies, "I know, and he never takes a chaser!" So it's very difficult to explain why I do what I do. I don't live any other life. It's like a chess player who has a chess player's head.

I can teach and explain to pupils what to do better, but not because there's a reason. I got experience from wonderful teachers in Russia, and then I just started working with my body and discovered that *this* was better than *that*. I improved, I could turn, I could do everything. Now I know *why* it's this way and not that way. But that's all. People like Stravinsky and Nabokov studied Roman law or Latin or German. They knew everything, and I didn't know anything! . . . Actually, though, I do remember that along with my training as a dancer, I had to recite speeches by Chekhov and Griboyedov, and only today do I remember these. When I talk to myself now, I can recite them and appreciate that beautiful language.

You once said: "Choreography is like cooking or gardening. Not like painting, because painting stays. Dancing disintegrates. Like a garden. Lots of roses come up, and in the evening they're gone. Next day, the sun comes up. It's life. I'm connected to what is part of life."

I don't care about my past. At all. I know people like La Karinska [Barbara Karinska, former head of the NYCB costume shop], who have everything, but who only talk about the past: "I remember how I was, I was pretty, I was this and that." I don't give a damn about the past. And the future . . . I wouldn't know what that is. To me, today is everything. Of course, I remember the speeches that I told you I learned as a child, I remember how to cook, I remember the dough that smelled so good. *Today* comes from the past, but in reality, it's all one thing to me.

The New York City Ballet is this year [1982] celebrating the 100th anniversary of Igor Stravinsky's birth with a series of old and new ballets set to his music. You and Stravinsky were always collaborators, and it is generally agreed that there was some kind of special affinity you had with his music, and he with your choreography—as if you were soul mates.

It's difficult for me to talk about soul—I just don't know. I know, however, that I liked his music, and I felt how it should be put into move-

ment. But our affinity with each other didn't have so much to do with soul but rather with understanding and eating food! We often had large dinners with "hookers" [Mr. Balanchine's term for a shot of vodka or whiskey] and caviar, and finally we got so that we could say dirty things, like everybody else [*laughing*]. But when we met to talk about his music, he'd play something and say, "This should be *this* way"—slow, fast, whatever. That's always what he did, ever since I first worked with him on *The Song of the Nightingale* in '24 or '25.

What was your first impression of Stravinsky?

First of all, I had great respect for him; he was like my father, since he was more than twenty years older than I. Stravinsky started playing the piece on the piano—*tha ta ta ta, tha tum ta tum*. . . . So I choreographed all that, and one day, Diaghilev came to see what I'd been up to and exclaimed: "No, that's the wrong tempo. Much slower!" So I changed the whole thing. Stravinsky came again, we played the piece slowly, and *he* said, "No, it's not right!" And I said that Mr. Diaghilev had told me to change it. Stravinsky jumped. So I rearranged the choreography again. I didn't know—I was very young, I'd never even heard the piece, I'd just come from Russia! And Matisse, whom I met . . . I didn't know who the heck Matisse was. Raphael, yes, but not Matisse! I didn't speak a word of French, but he seemed like a nice man with a beard.

Anyway, I worked with Stravinsky again on *Apollo*, and then I came to America. . . . Oh, yes, I remember meeting him in Nice, and that was easy because he spoke Russian. I had lunch at his house with his priest and the priest's wife—white clergy were allowed to marry, but not black clergy. My uncle was Archbishop of Tbilisi, by the way. And I remember that the first time he learned he was going to be a monk, he went down on the floor and was covered with black crepe. So, at that moment, he was dead to the world. Then the people helped him get up, and they took him away.

You yourself were an altar boy at church.

Yes, and I liked it. And at home, I even played priest with two chairs beside me. I liked the ceremony and the way the priests dressed. I was five or six then.

But you became a choreographer instead. Do you think there's a connection?

There is. Our church services were elaborate, like productions. They

really were like plays with beautiful singing and choruses . . . You know, I've just finished choreographing Stravinsky's *Perséphone*, and at the end, I bring the boys onstage—the chorus is there and nobody's doing anything—and I light them from the bottom up, so you can see their faces, as if they're candles in church.

So your childhood love of church influenced your ballets.

Oh, yes.

Stravinsky was religious. Are you?

I don't tell anyone, but I go to church by myself.

Stravinsky used to say that he believed in the devil.

Not the Devil. The devil exists, but not the Devil. The devil only stands for the negative.

Stravinsky once wrote: "What are the connections that unite and separate music and dance? In my opinion, the one does not serve the other. There must be a harmonious accord, a synthesis of ideas. Let us speak, on the contrary, of the struggle between music and choreography."

Absolutely! Struggle means to be together. It's not so easy to unite and to be together. When you're *immediately* together, it's [*claps hands*] and you evaporate. Stravinsky's right.

You see, if you look at the dances that most dance makers or ballet masters make, the music is used as background, basically . . . like movie music or television music. Who are the ballet masters? Unsuccessful dancers. Not all of them, but hundreds and hundreds everywhere. They open a school and they teach badly because they didn't dance very well themselves. But to be a choreographer, you must be a great dancer— maybe not *great*, but better than the dancers who come to you. Because you have to invent and teach these people something that they don't know. Otherwise, you use the steps of somebody else.

I remember that with the GI Bill of Rights, the government would send us people they didn't want to take into the Army, and they paid us to take them—we *had* to take them. Sixty boys would come to us. And there was one young man who approached me and asked how one became a choreographer. Well, I told him it was very difficult: you had

to learn how to dance very well, better than all other dancers. And then, God blesses you, gives you something, helps you to refine what's there. And he replied: "I want to be a choreographer first. I don't want to learn anything. I want to sit and tell everybody what to do." Lots of boys were like that.

So it's no use even to talk about it. It's like everybody wants to write a book. *I've* even written a book, but I didn't really write it: I sat down and conversed with a nice writer, and he wrote something. So not everybody should be a choreographer. To take music and just use it as a background and have people dance to it . . . it's not right if it doesn't represent anything.

So struggle means respecting dance and music.

Yes, struggle means you have to be right in the way you put them together.

Then each of your works with Stravinsky is a struggle with his music?

Absolutely. After he finished the scores, he gave them to me. I would visit his home in California, and we'd talk. "What do you want to do?" he'd ask, and I'd say, "Supposing we do *Orpheus*." "How do you think *Orpheus* should be done?" "Well," I'd say, "a little bit like opera. Orpheus is alone, Eurydice is dead, he cries, an angel comes and takes him to the underworld, and then Orpheus returns to earth. But he looks back, and she disappears forever."

Well, we tried to do that. And Stravinsky said, "I'll write the end first; I sometimes have an appetite to write the end first." And that's what he did, with the two horns—it's a beautiful thing, sad, hair flowing. We couldn't have a river on the stage, but it suggests something like that.

Then he asked, "Now, how to begin?" And I said, "Eurydice is in the ground, she's already buried, Orpheus is sad and cries—friends come to visit him, and then he sings and plays." "Well," Stravinsky asked, "how long does he play?" And I started to count [*snaps fingers*], the curtain goes up. "How long would you like him to stand without dancing, without moving? A sad person stands for a while, you know." "Well," I said, "maybe at least a minute." So he wrote down "minute." "And then," I said, "his friends come in and bring something and leave." "How long?" asked Stravinsky. I calculated it by walking. "That will take about two minutes." He wrote it down.

And it went on like that. He'd say, "I want to know how *long* it should be." "It could be a little longer," I'd tell him, "but at least it's not forever!" And later he played one section for me, and I said, "It's a little bit too short." "Oh, oh," he'd sigh, "I already orchestrated it, and it's all finished. . . . Well, I'll do something, I know what to do." "Ah, thank you!" I replied. Things like that, you see: "How long?" he'd say. "One minute and twenty seconds," I'd tell him. "Twenty-*one*," he'd say, and smile. And I'd agree, "Fine, twenty-one!"

Stravinsky is more complicated than I am, because the body doesn't have the possibilities that music has in terms of speed. A pianist can play fast, but the body can't go that quickly. The body's different from music. Supposing you start moving fast, like sixty-fourth notes. But you can't, you can't see it. Eyes can't really see peripherally, the movement passes and is gone. So we have to calculate movements. To hear and to see isn't the same thing. You have to have extremely fantastic eyes to see everything.

But perhaps it's better not to talk about. Horses don't talk, they just go! We want to win the race. And how? With energy, training, and dancing!

[Summer, 1982]

Three Sides of *Agon*

EDWIN DENBY

I

Agon, a ballet composed by Igor Stravinsky in his personal twelve-tone style, choreographed by George Balanchine, and danced by the New York City Ballet, was given an enormous ovation last winter by the opening-night audience. The balcony stood up shouting and whistling when the choreographer took his bow. Downstairs, people came out into the lobby, their eyes bright as if the piece had been champagne. Marcel Duchamp, the painter, said he felt the way he had after the opening of *Le Sacre*. At later performances, *Agon* continued to be vehemently applauded. Some people found the ballet set their teeth on edge. The dancers show nothing but coolness and brilliantly high spirits.

Agon is a suite of dances. The score lasts twenty minutes, and never becomes louder than chamber music. On stage the dancers are twelve at most, generally fewer. The ballet has the form of a small entertainment, and its subject—first, an assembling of contestants, then the contest itself, then a dispersal—corresponds to the three parts into which the score is divided.

The subject is shown in terms of a series of dances, not in terms of a mimed drama. It is shown by an amusing identity in the action, which is classic dancing shifted into a "character" style by a shift of accentuation. The shift appears, for example, in the timing of transitions between steps or within steps, the sweep of arm position, in the walk, in the funniness of feats of prowess. The general effect is an amusing deformation of classic shapes due to an unclassic drive or attack; and the drive itself looks like a basic way of moving one recognizes. The "basic gesture" of *Agon* has a frank, fast thrust like the action of Olympic athletes, and it also has a loose-fingered goofy reach like the grace of our local teenagers.

The first part of the ballet shows the young champions warming up. The long middle part—a series of virtuoso numbers—shows them rivalizing in feats of wit and courage. There is nothing about winning or losing. The little athletic meet is festive—you watch young people

competing for fun at the brief height of their power and form. And the flavor of time and place is tenderly here and now.

II

Agon shows that. Nobody notices because it shows so much else. While the ballet happens, the continuity one is delighted by is the free-association kind. The audience sees the sequence of action as screwball or abstract, and so do I.

The curtain rises on a stage bare and silent. Upstage four boys are seen with their backs to the public and motionless. They wear the company's dance uniform. Lightly they stand in an intent stillness. They whirl, four at once, to face you. The soundless whirl is a downbeat that starts the action.

On the upbeat, a fanfare begins, like cars honking a block away; the sound drops lower, changed into a pulse. Against it, and against a squiggle like a bit of wallpaper, you hear—as if by free association—a snatch of *Chinatown, My Chinatown* misremembered on an electric mandolin. The music sounds confident. Meanwhile the boys' steps have been exploding like pistol shots. The steps seem to come in tough, brief bursts. Dancing in canon, in unison, in and out of symmetry, the boys might be trying out their speed of waist, their strength of ankle; no lack of aggressiveness. But already two—no, eight—girls have replaced them. Rapidly they test toe power, stops on oblique lines, jetlike extensions. They hang in the air like a swarm of girl-size bees, while the music darts and eddies beneath them. It has become complex and abstract. But already the boys have re-entered, and the first crowding thrust of marching boys and leaping girls has a secret of scale that is frightening. The energy of it is like that of fifty dancers.

By now you have caught the pressure of the action. The phrases are compact and contrasted; they are lucid and short. Each phrase, as if with a burst, finds its new shape in a few steps, stops, and at once a different phrase explodes unexpectedly at a tangent. They fit like the stones of a mosaic, the many-colored stones of a mosaic seen close-by. Each is distinct, you see the cut between; and you see that the cut between them does not interrupt the dance impetus. The novel shapes before you change as buoyantly as the images of a dream. They tease. But like that of a brilliant dream, the power of scale is in earnest. No appeal from it.

While you have been dreaming, the same dance of the twelve dancers has been going on and on, very fast and very boring, like travel in outer space. Suddenly the music makes a two-beat cadence and stops. The

dispersed dancers have unexpectedly turned toward you, stopped as in a posed photograph of athletes; they face you in silence, vanish, and instantly three of them stand in position to start a "number" like dancers in a ballet divertissement.

The music starts with a small circusy fanfare, as if it were tossing them a purple-and-red bouquet. They present themselves to the public as a dance team (Barbara Milberg, Barbara Walczak, Todd Bolender). Then the boy, left alone, begins to walk a *Sarabande*, elaborately coiled and circumspect. It recalls court dance as much as a Cubist still life recalls a pipe or guitar. The boy's timing looks like that of a New York Latin in a leather jacket. And the cool lift of his wrong-way-round steps and rhythms gives the nonsense so apt a turn people begin to giggle. A moment later one is watching a girls' duet in the air, like flying twins *(haute danse)*. A trio begins. In triple canon the dancers do idiotic slenderizing exercises, theoretically derived from court gesture, while the music foghorns in the fashion of *musique concrète*. Zanily pedantic, the dance has the bounce and exuberant solemnity of a clown act. The audience laughs, applauds, and a different threesome appears (Melissa Hayden, Roy Tobias, Jonathan Watts).

For the new team the orchestra begins as it did for the previous one— first, the pushy, go-ahead fanfare, then the other phrase of harmonies that keep sliding without advancing, like seaweed underwater. (The two motifs keep returning in the score.)

The new team begins a little differently and develops an obvious difference. The boys present the girl in feats of balance, on the ground and in the air, dangerous feats of lucid nonsense. Their courage is perfect. Miss Hayden's deadpan humor and her distinctness are perfect, too. At one point a quite unexpected flounce of little-girl primness as in silence she walks away from the boys endears her to the house. But her solo is a marvel of dancing at its most transparent. She seems merely to walk forward, to step back and skip, with now and then one arm held high, Spanish style, a gesture that draws attention to the sound of a castanet in the score. As she dances, she keeps calmly "on top of" two conflicting rhythms (or beats) that coincide once or twice and join on the last note. She stops and the house breaks into a roar of applause. In her calm, the audience has caught the acute edge of risk, the graceful freshness, the brilliance of buoyancy.

The New York audience may have been prepared for *Agon*'s special brilliance of rhythm by that of *Opus 34* and *Ivesiana*, two ballets never shown on tour. All three have shown an acuteness of rhythmic risk never seen and never imagined outside the city limits. The dangerous-

ness of *Agon* is as tense as the danger of a tightrope act on the high wire. That is why the dancers look as possessed as acrobats. Not a split-second leeway. The thrill is, they move with an innocent dignity.

At this point of *Agon*, about thirteen minutes of dancing have passed. A third specialty team is standing onstage ready to begin (Diana Adams, Arthur Mitchell). The orchestra begins a third time with the two phrases one recognizes, and once again the dancers find in the same music a quite different rhythm and expression. As the introduction ends, the girl drops her head with an irrational gesture more caressing than anything one has seen so far.

They begin an acrobatic adagio. The sweetness is athletic. The absurdity of what they do startles by a grandeur of scale and of sensuousness. Turning pas de deux conventions upside down, the boy with a bold grace supports the girl and pivots her on pointe, lying on his back on the floor. At one moment, classic movements turned inside out become intimate gestures. At another, a pose forced way beyond its classic ending reveals a novel harmony. At still another, the mutual first tremor of an uncertain supported balance is so isolated musically it becomes a dance movement. So does the dangerous scoop out-of-balance and back into balance of the girl supported on pointe. The dance flows through stops, through scooping changes of pace, through differences of pace between the partners while they hold each other by the hand. They dance magnificently. From the start, both have shown a crescendo and decrescendo within the thrust of a move, an illusion of "breath" — though at the scary speed they move such a lovely modulation is inconceivable. The fact that Miss Adams is white and Mr. Mitchell Negro is neither stressed nor hidden; it adds to the interest.

The music for the pas de deux is in an expressive Viennese twelve-tone manner, much of it for strings. Earlier in the ballet, the sparse orchestration has made one aware of a faint echo, as if silence were pressing in at the edge of music and dancing. Now the silence interpenetrates the sound itself, as in a Beethoven quartet. During the climactic pas de deux of other ballets, you have watched the dancer stop still in the air, while the music surges ahead underneath; now, the other way round, you hear the music gasp and fail, while the two dancers move ahead confidently across the open void. After so many complex images, when the boy makes a simple joke, the effect is happy. Delighted by the dancers, the audience realizes it "understands" everything, and it is more and more eager to give them an ovation.

There isn't time. The two dancers have become one of four couples who make fast, close variations on a figure from the pas de deux. The

action has reverted to the anonymous energy you saw in the first part. Now all twelve dancers are onstage and everything is very condensed and goes very fast. Now only the four boys are left; you begin to recognize a return to the start of the ballet; you begin to be anxious, and on the same wrestler's gesture of "on guard" that closed their initial dance—a gesture now differently directed—the music stops, the boys freeze, and the silence of the beginning returns. Nothing moves.

During the stillness, the accumulated momentum of the piece leaps forward in one's imagination, suddenly enormous. The drive of it now seems not to have let up for a moment since the curtain rose. To the realization of its power, as the curtain drops, people respond with vehement applause in a large emotion that includes the brilliant dancers and the goofiness of the fun.

The dancers have been "cool" in the jazz sense—no buildup, inventions that did not try to get anywhere, right after a climax an inconsequence like the archness of high comedy. But the dramatic power has not been that of jokes; it has been that of unforeseeable momentum. The action has had no end in view—it did not look for security, nor did it make any pitiful appeal for that. At the end, the imaginary contestants froze, toughly confident. The company seems to have figured jointly as the off-beat hero, and the risk as the menacing antagonist. The subject of *Agon*, as the poet Frank O'Hara said, is pride. The graceful image it offers is a buoyance that mystifies and attracts.

III

A program note says that "the only subject" of the ballet is an interpretation of some French seventeenth-century society dances. The note tells you to disregard the classic Greek title *(Agon)* in favor of the French subtitles. It is a pity to. The title and the subtitles are words that refer to civilized rituals, the former to athletics, the latter to dancing. Athletic dancing is what *Agon* does. On the other hand, you won't catch anyone onstage looking either French or Greek. Or hear musically any reason they should. French Baroque manners and sentiments are not being interpreted; elements or energies of forms are.

The sleight-of-hand kind of wit in the dancing is a part of that "interpretation." You see a dancer rushing at top speed, stop sharp in a pose. The pose continues the sense of her rush. But the equilibrium of it is a trap, a dead end. To move ahead, she will have to retract and scrounge out. She doesn't, she holds the pose. And out of it, effortlessly, with a grace like Houdini's, she darts away. The trap has opened in an

unforeseen direction, as music might by a surprising modulation. At times in *Agon* you see the dancer buoyantly spring such traps at almost every step. Or take the canonic imitations. At times a dancer begins a complex phrase, bristling with accents, and a second dancer, leaping up and twisting back an eighth note later, repeats it, then suddenly passes a quarter note ahead. The dissonance between them doesn't blur; if you follow it, you feel the contradictory lift of the double image put in doubt where the floor is. Or else you see a phrase of dance rhythm include a brief representational gesture, and the gesture's alien impetus and weight—the "false note" of it—make the momentum of the rhythm more vividly exact. These classic dissonances (and others you see) *Agon* fantastically extends. The wit isn't the device, it is the surprise of the quick lift you feel at that point. It relates to the atonal harmonies of the score—atonal harmonies that make the rhythmic momentum of the music more vividly exact.

At times you catch a kind of dissonant harmony in the image of a step. The explosive thrust of a big classic step has been deepened, speeded up, forced out farther, but the mollifying motions of the same step have been pared down. In a big step in which the aggressive leg action is normally cushioned by mildly rounded elbows, the cushioning has been pared down to mildly rounded palms. The conciliatory transitions have been dropped. So have the transitional small steps. Small steps do not lead up to and down from big ones. They act in opposition to big ones, and often stress their opposition by a contrariness.

The patterns appear and vanish with an unpredictable suddenness. Like the steps, their forms would be traditional except for the odd shift of stress and compactness of energy. The steps and the patterns recall those of Baroque dancing much as the music recalls its Baroque antecedents—that is, as absurdly as a current Harvard student recalls a Baroque one. Of course, one recognizes the relation.

Agon shifts traditional actions to an off-balance balance on which they swiftly veer. But each move, large or small, is extended at top pitch. Nothing is retracted. The ardent exposure is that of a grace way out on a limb.

The first move the dancers make is a counteraccent to the score. Phrase by phrase, the dancers make a counterrhythm to the rhythm of the music. Each rhythm is equally decisive and surprising, equally spontaneous. The unusualness of their resources is sumptuous, like a magnificent imaginative weight. One follows the sweep of both by a fantastic lift one feels. The Balanchinean buoyancy of impetus keeps one open to the vividly changeable Stravinskyan pressure of pulse and to its momen-

tum. The emotion is that of scale. Against an enormous background one sees detached for an instant the hidden grace of the dancer's individual move, a chance event that passes with a small smile and a musical sound forever into nowhere.

1957
From *Dancers, Buildings and People in the Streets*

Acknowledgments

The publication of *Portrait of Mr. B* has been made possible in part by generous gifts from Gillian Attfield, Mr. & Mrs. Sid R. Bass, the Eakins Press Foundation, the Lassalle Fund, and Lila Acheson Wallace.

Ballet Society wishes to acknowledge the contributions of Susan Au, Richard Benson, Robert Cornfield, Leslie George Katz, Nancy Lassalle, and Thomas W. Schoff in the preparation of *Portrait of Mr. B*.

Thanks are also due to Erik Aschengreen, Richard Buckle, Susan Cook, Diana Davies, Philip Dyer, Mary Fraker, Bengt Häger, John R. Johnsen, Sandra Limoncelli, Genevieve Oswald, Nancy Reynolds, Elisabeth Scharlatt, Jerry Thompson, Henry Wisneski, and Helen Wright for their invaluable assistance.

Photographs and information were graciously provided by the Dance Collection of The New York Public Library, the Dansmuseet, Stockholm, and the Theatre Museum of the Victoria and Albert Museum, London.

Designed by Howard I. Gralla

Reproduction supervised by Richard Benson

Production directed by
the Eakins Press Foundation

Text composed and printed by letterpress
in Centaur and Bembo types at
The Stinehour Press

Photographs printed at
The Meriden Gravure Company